MASS EFFECT™

The Official Cocktail Book

MASS EFFECT™

The Official Cocktail Book

Recipes by Cassandra Reeder
Text by Jim Festante

INSIGHT
EDITIONS

SAN RAFAEL · LOS ANGELES · LONDON

CONTENTS

Silver Coast Casino

Weeping Heart

The Mindfish

Volus Bina

Thessian Temple

Asari Gelatin Shots

Krogan Burukh

Normandy Crew Concoctions

Subject Zero

Calibration Cooler

Quantum Entanglement

Joker's Challenge

Emergency Induction Port

The N7 Shooter

Milky Way Bar Snacks

EDI's Curry Snacks

Burgat: The Other Blue Meat

Tastee Bites

Herbed Dextro Cheese

Huevos Rancheros à la Vega

Spicy Ramen Noodles

Kaidan's Steak Sandwich

Ryuusei Roll Spéciale

Chocolate Lava Bomb Cake

Andromeda:

Added in 2819 by Roa, Andromeda citizen and Nexus exchange volunteer

The Vortex

Tall Moose

Dirty Squirrel

Lucky Leprechaun

Pink Marble

Rotten Scoundrel

Kralla's Song

Combat Juice

Umi's Experiment

Hot Spiced Tavum

Tavum & Juice

Akantha Fizz

Tartarus

Marljeh

Kadara Sunrise

Drossix Blue

Slumwater

Andromeda Bar Snacks

"Gingerbeard" Cookies

Varren Steak Bites

Movie Night! Tarvav, Popcorn & Graxen

Yanjem's Sweet Dumplings

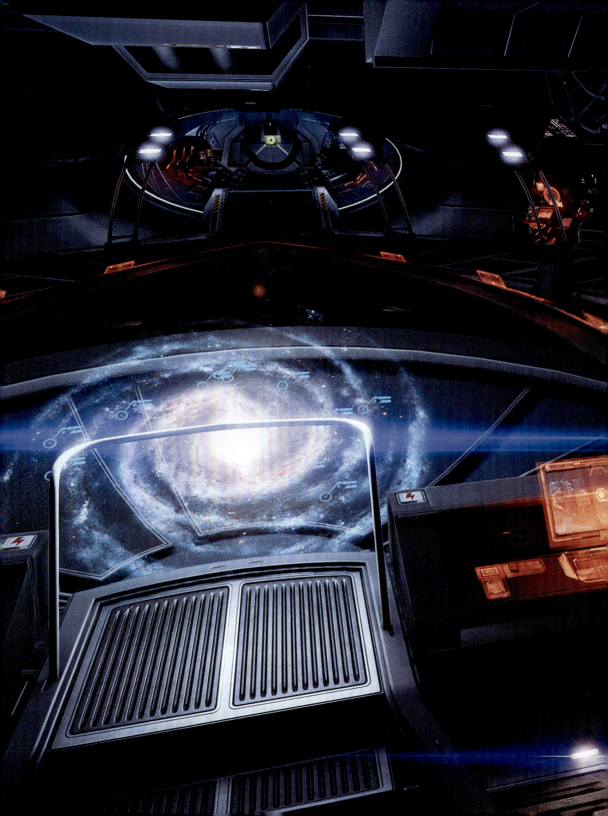

INTRODUCTION

It's a big galaxy out there. Numerous planets and their inhabitants, all jockeying for power, prestige, and precedence. With these competing agendas often clashing, seldom mixing, sometimes you need a swig of something stiff to get you to the next Relay. Well, you've come to the right place.

And me? Nine hundred years (give or take) and a variety of careers and aliases later, I hustle my way through the galaxy by the name Ambree T'Sia these days. It's the one fiction that allows me to keep the rest of the story honest—with varying degrees, depending on the situation. What I can share is this: a former asari huntress, I left the military bureaucracy to lead a small covert unit of ex-commandos focused on espionage and assassination outside of official channels. More effective and more fun that way. In my earlier years, I quickly learned that the best way to collect information is to buy a merc a drink or talk to the entertainers. The more I relied on bars and nightclubs to gather intel, the more connections I made with the key players. Not just the ones in the back office, but the ones slinging drinks with closed mouths and open ears. I started posing as a bartender myself and got quite good at it. Enjoyed it, even. I couldn't exactly stay put for, well, reasons. But among those in the know, I'm still the go-to source for recommendations about the Milky Way's best bars and nightclubs. After one too many "you should write a book!" jokes, I did. Guns and bribes in this economy? A cocktail guide seemed like an ideal little side hustle to help fund my more targeted activities.

With this pen name, I'm free to share my favorite anecdotes about well-known figures across civilizations. I've also included a few safety tips for surviving the galaxy, setting your drink on fire, or respecting local drinking ages. (If you're not legal, close this book up and come back when you are, babe.) I guess I just don't believe in accidental injuries.

For those feeling brave, go ahead and speculate about who I truly am. I'm not worried in the least. Because you won't guess, and I'll never tell . . .

—"Ambree T'Sia"

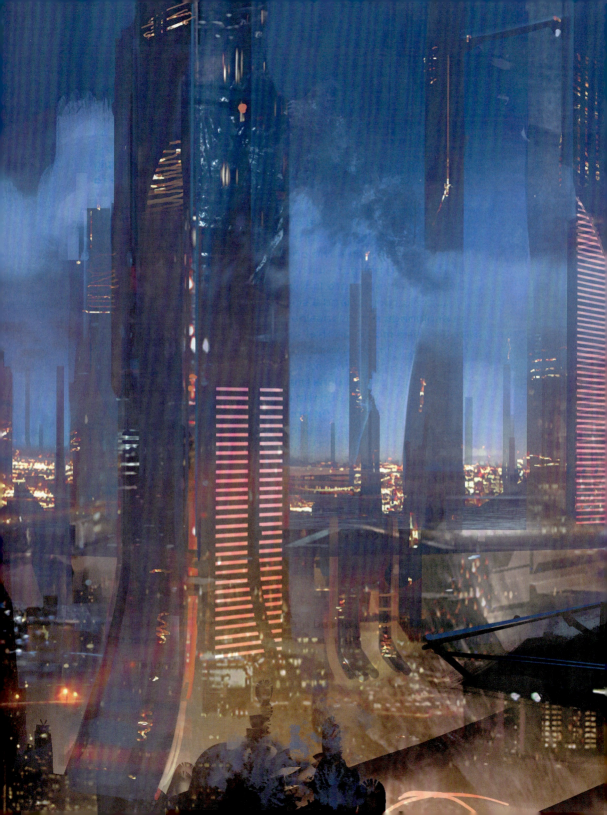

MIXERS

Whether you're slinging the hard stuff or milder "hair of the FENRIS Mech that bit you" drinks, mixers are the essential building blocks to any good bar. By all means, keep your favorite fruit juices, sodas, and whatnots on hand. But as someone who tends to move around a lot due to my . . . profession (I'm a master of the Asari Goodbye), I tend to lead a minimalist lifestyle. As such, I keep these mixer recipes on file to prepare quickly, as I need them. Let's just say that they'll keep your cocktails interesting.

BLUE THESSIA

Yes, mama is supposed to love all her babies the same, but this mixer is my favorite for its taste and versatility. (Hmm ... sound like any cocktail authors you know?) Named after the asari homeworld, the Blue Thessia is the crown jewel of your bar essentials. You'll predominantly taste sweet juniper and recognize that bold, asari-blue color. You could make your drinks without Blue Thessia, but that's programming a Quantum Blue Box type AI and not giving it a sexy voice. What a wasted opportunity! Do be aware that this one contains trace amounts of element zero—nothing to concern yourself about, though, and it does keep things nice and sparkly.

 YIELD:
8 to 12 drinks

¼ cup granulated sugar
8 dried butterfly pea flowers
1 cup dry gin or water (must be alkaline)
⅛ teaspoon white luster dust

Special Equipment:
Mason jar or glass bottle
Fine-mesh strainer

1. In a sanitized mason jar or glass bottle with a secure lid, add the sugar and the butterfly pea flowers.

2. Add the gin to the bottle. Let infuse overnight.

3. Strain the liquid through a fine-mesh strainer. Discard the flowers.

4. Add the luster dust to the liqueur. Secure the lid and shake to combine.

5. Store in the refrigerator for 1 to 2 weeks.

TUCHANKA DRY

This is the good stuff and it's *very* hard to come by, which is why I make my own. Tuchanka Dry is similar to a fat-washed bourbon, which not only adds the flavor of the fat to the spirit, but also its texture and weight. If you're making a Full Biotic Kick (page 43), well, this part's the "kick." Traditionally made with Thresher Maw fat (I did say it was hard to come by), this recipe started as a krogan rite-of-passage celebratory drink, when leftover fat from the kill was mixed together with alcohol. If you prefer dodging grocery carts over acid spit, you can make your own and get a surprisingly similar taste by substituting bacon.

YIELD:
8 to 12 drinks

½ cup bacon fat or butter
2 cinnamon sticks
1 or 2 allspice berries
1 star anise (optional)
1 cup bourbon
1 vanilla pod or 2 teaspoons vanilla extract
1 teaspoon orange zest
2 tablespoons Simple Syrup (page 13) (optional)

Special Equipment:
Medium pan
Fine-mesh strainer
Cheesecloth
Mason jar or glass bottle

1. In a medium pan, heat the bacon fat or butter, along with the cinnamon sticks, allspice berries, and star anise (if applicable) over medium-high heat until melted. If using butter, stir constantly until the butter starts to brown. Once the butter has reached a dark caramel color, in about 2 to 4 minutes, remove it from the heat and let cool for 10 minutes.

2. Pour the bacon fat or butter and spices into a mason jar or 2-cup glass storage container and add the bourbon, vanilla, and orange zest. Put the lid on the container and give it a quick shake. Let the mixture sit at room temperature for 30 minutes or up to 1 hour, then transfer it to the refrigerator.

3. Let the mixture cool overnight until the butter or bacon fat has formed a hard layer on top of the booze.

4. Remove the fat layer from the bourbon. This can be discarded or saved to be used for cooking.

5. Pass the liquid through a fine-mesh strainer lined with cheesecloth to remove any remaining solids. Stir in the simple syrup to taste, if using.

6. Store the liquid in a mason jar or glass bottle with a tight-fitting lid for up to 2 weeks.

HORSE CHOKER

I've often found fighter pilots to be aggressive and competitive, so it delights me that this recipe I procured from a hot-tempered Alliance pilot named Jeff "Joker" Moreau is instead indulgent and harmonious. The chocolate and espresso flavors combined with the spiced rum work oh so well together in a luxurious cooperation that especially enhances minty drinks. But don't take my word for it—if you're feeling a little spicy and hot-tempered, you might find this mixer helpful when you toss back a few shots of Joker's Challenge (page 98) with your closest frenemies.

YIELD:
8 to 12 drinks

1 cup black spiced rum

¼ cup cacao nibs

⅛ cup espresso beans

1 vanilla pod or 2 teaspoons vanilla extract

2 tablespoons Simple Syrup (page 13) (optional)

Special Equipment:

Mason jar

Fine-mesh strainer

1. In a sanitized mason jar, add the rum, cacao nibs, espresso beans, and vanilla and seal.

2. Let the rum infuse in a cool, dark place for at least 48 hours, up to 1 week. Shake the jar lightly once or twice per day. Check the flavor after 48 hours.

3. Once the flavor is strong enough for you, strain the rum through a fine-mesh strainer. Add the simple syrup to taste to the jar and store it in the refrigerator for up to 2 weeks.

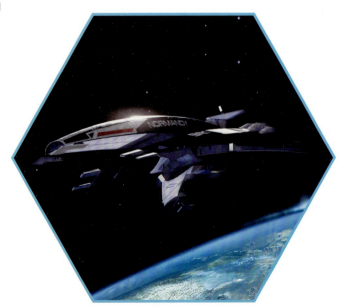

SIMPLE SYRUP

An essential building block for cocktails. Any well-stocked bar has a traditional simple syrup on hand. If you're new to cocktail making and a bit apprehensive, start here—just add sugar to boiling water. See? Simple. As you'll see, I prefer twice as much sugar to water. It's on the richer side and your mileage may vary, as they say. Be aware that you don't want to let too much water evaporate, or the syrup will reduce and cook down to something resembling krogan poetry: thicker and sweeter than expected. (Try to get past one stanza of *Blue Rose of Illium* without rolling your eyes out of their sockets, I dare you.)

YIELD:
4 to 32 drinks

1 cup purified water
2 cups granulated sugar

Special Equipment:
Medium pot
Glass bottle or jar

1. In a medium pot, bring the water to a boil.

2. Dissolve the sugar in the boiling water, stirring constantly.

3. Once the sugar has dissolved, reduce the heat, cover, and let simmer for about 5 to 7 minutes.

4. Remove the pan from the heat and allow the mixture to cool to room temperature.

5. Store in a glass bottle or jar with a tight-fitting lid for up to 1 month in the refrigerator.

SALARIAN
SALINATION SOLUTION

Successfully made your way through the Simple Syrup recipe (page 13) but still feel like you need one more easy win? Perhaps a mixer that's ideal for citrus-heavy cocktails? Make this bartender's saline next and keep in mind that science doesn't always have to be complicated. Science is also very useful, and you'll find this mixer in a variety of recipes throughout this book. (For the more adventurous, the Liquified Turian on page 57 is a must.) Now, if you think adding sea salt to warm water isn't exactly "science," then your name isn't Sel Vass—a double-crossing salarian bartender who fancies himself an "intoxicologist." I have . . . thoughts on that, which is why I've named this Salarian Salination Solution after him. And if your name *is* Sel Vass, I'm going to add your kidneys to my next bar menu— preferably with you still alive. (I've heard that when the Protheans did this to your ancestors, they found the fear adds "spice.")

YIELD:
25 to 35 drinks

⅓ cup warm purified water (bottled or filtered)

1 tablespoon sea salt

Special Equipment:

Microwave-safe container or saucepan

Dropper bottle or empty bitters bottle

1. In a microwave or saucepan, heat the purified water to around 105°F to 110°F (just warm enough that salt will dissolve easily).

2. Add the sea salt to the warm water and stir until the solution is clear.

3. Let cool, then transfer to a dropper bottle or empty bitters bottle.

TUPO CONCENTRATE

I love a good Tupo Concentrate: it has a delicious balance of mouth-puckering tartness and euphoric sweetness. The only problem? I can never find any berries! Tupari sports drink–makers horde as much as they can to sell "12 trillion bottles per day," despite only containing 10 percent real tupo juice (goddess only knows what the other 90 percent of that swill is). Fortunately, grenadine is a perfect substitute for when you're looking to add a beautiful hue and unexpected depth of flavor to your cocktail.

 YIELD:
4 to 32 drinks

2 cups pomegranate juice
1 tablespoon lemon juice
2 cups granulated sugar
2 dashes orange flower water (optional)

Special Equipment:
Medium saucepan
Small jar or glass bottle

1. In a medium saucepan, combine the pomegranate juice, lemon juice, and sugar.

2. Bring the mixture to a slow boil, stirring constantly, until all the sugar has dissolved.

3. Reduce the heat and cover. Simmer on low for 10 to 15 minutes, stirring occasionally.

4. Allow the mixture to cool, then pour it into a small jar or glass bottle with a tight-sealing lid.

5. Add the orange flower water (if using) and seal the container. Give it a couple shakes.

6. Let cool before using. Store in the refrigerator for up to 3 weeks.

DRELL SKIN VENOM

Like bitters, Drell Skin Venom adds a nice bite, making your cocktail extraordinarily complex with just a few drops. Now, you might think that enough Drell Skin Venom may grant the memory-recall properties of its erstwhile secretor, but it's more likely that the high alcohol content (which keeps it in heavy rotation at swanky bars like the Silver Coast Casino) will create more plot holes in your life than the salarian extranet drama *Dynasty of Stars* (with the same amount of nausea—stick to science, you excitable little amphibians!).

 YIELD:
30 to 35 drinks

¼ cup Szechuan peppercorns, lightly crushed

2 whole cloves

1 teaspoon dried mint

1 teaspoon red pepper flakes

¼ teaspoon grated nutmeg

2-inch piece lemon peel, scrubbed and pith removed

½ cup neutral grain alcohol or high-proof vodka

Special Equipment:
Glass bottle or mason jar
Cheesecloth
Dropper bottle or empty bitters bottle

1. In a glass bottle or mason jar with a tight-fitting lid, add the herbs, spices, and lemon peel. Pour in the grain alcohol. Seal the jar and give it a swirl or light shake to mix the ingredients.

2. Allow the mixture to infuse for 1 to 2 weeks. Shake it lightly once or twice per day.

3. Strain the infused alcohol into a clean jar through cheesecloth to remove the botanicals, squeezing it to release as much liquid as possible.

4. Transfer to a dropper bottle or an empty bitters bottle. This mixture can be stored for up to 1 year.

ASARI HONEY SYRUP

For the occasions where you're looking to spice things up, I'd suggest using this honey syrup. It's just as versatile as its simple syrup sister but adds a bit more flavor. This particular mixer has a spicy little background as well: the original recipe was made in an Ardat–Yakshi monastery and its honeyed flavor is as alluring as its makers. Considering said makers enjoy nothing less than total domination, however, this syrup is unexpectedly collaborative with numerous drinks and flavors.

 YIELD:
8 to 16 drinks

½ cup water

½ cup honey

1 or 2 sticks cinnamon

½ teaspoon nutmeg

½ teaspoon roasted or smoked cinnamon (optional)

1 orange, zested

2 sage leaves or 1 sprig rosemary (optional)

1 vanilla pod or 1 teaspoon vanilla extract

Special Equipment:
Medium pot
Fine–mesh strainer
Glass bottle or jar

1. In a medium pot, add all the syrup ingredients and bring to a boil over medium heat. Reduce the heat to low and simmer for 3 to 4 minutes until the syrup has reduced, then remove it from the heat. Set aside to cool.

2. Once the syrup has cooled, pour the mixture through a fine–mesh strainer and a funnel into a glass bottle or jar with a tight–fitting lid.

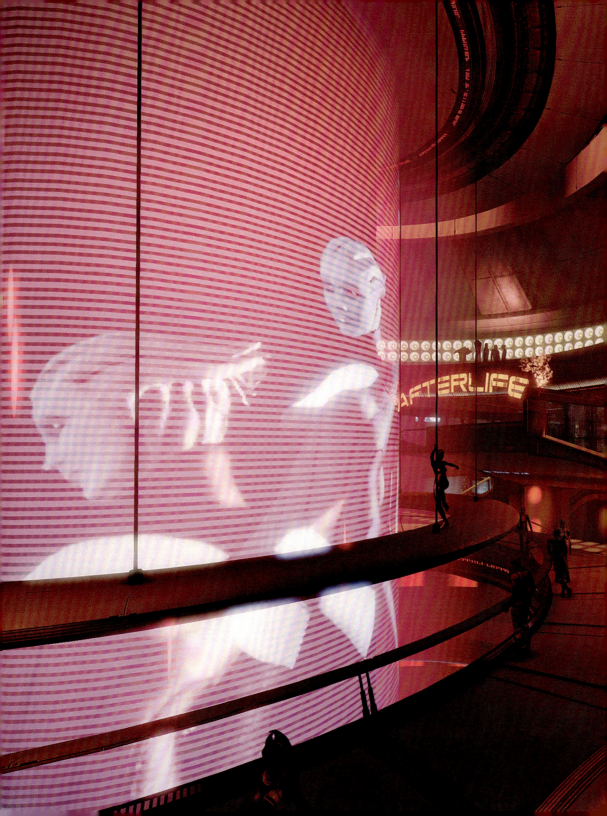

AFTERLIFE CLUB

What is Afterlife? Why, the ultimate in illicit entertainment. Iconic, chic, ready to show you a good time . . . but mind your manners. Under all that polish, Afterlife is seething with violence just under the surface. A locus of power and secrecy—is it any wonder the glitzy club sports an ethic of violence and greed?

And that's just how this nightclub's patrons, and its Pirate Queen, prefer things. Aria T'Loak oversees this particular multilevel palace of paradise and perdition on the space station Omega. And yes, its lure entices millions around the galaxy to leave their ordinary lives for extraordinary adventures, so be sure to show her the proper respect. She's shot people she liked far more for way less. The recipes in this section are her top sellers—perfect for when you'd rather spend the night in than risk getting poisoned by a batarian bartender with a grudge against humans.

THE OMEGA SLING

This cocktail is a personal favorite of mine from Afterlife for a reason. It's sweet, tart, bitter, fruity, and spicy all at once. A complex little thing, and a single-serving punch that can also pack one. While it's definitely a drink made to impress (look at that list of ingredients!), for me, it tastes like personal accomplishment. I once led a raid on a CAT6 outpost that nabbed enough high-end military gear to outfit my crew for a long, long time. It was a bastard to plan, just like the Omega Sling, but that only made the victory that much sweeter.

 SERVES: 1 **ICE:** Collins spear ice or standard, 1-inch cubes **GLASS:** Sling, collins, or highball

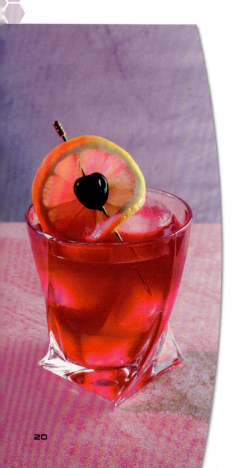

2 ounces navy-strength gin

2 ounces pomegranate juice

¾ ounce cinnamon whiskey

¾ ounce maraschino liqueur

½ ounce lemon juice

3 to 4 dashes aromatic bitters

4 to 5 dashes Drell Skin Venom (page 16) or other spicy bitters

Garnish:

1 thin lemon slice

1 Luxardo or bourbon cherry

1. Add the drink ingredients to a cocktail shaker filled with ice.

2. Shake for 15 to 20 seconds until well chilled and slightly frothy.

3. Strain into a glass filled two-thirds of the way with standard ice or use a collins spear.

4. Skewer a lemon slice and cocktail cherry to garnish.

BLUE SUN SPRITZ

Did you know that the Blue Suns mercenary group was founded by a batarian named Solem Dal'serah? That's the public-facing story they'd prefer you believe, at least. And to celebrate said founding, Solem toasted the group with this hard-hitting wine spritz. The color ends up being a rich deep blue—a little on the nose, maybe, but it lands most satisfyingly on the tongue.

 SERVES: 1 **ICE:** Collins spear ice or standard, 1-inch cubes **GLASS:** Highball

1 ounce navy-strength gin

¾ ounce dry vermouth

¾ ounce white wine aperitif

½ ounce blue curaçao

2 to 3 dashes grapefruit or orange bitters (optional)

3 to 4 ounces sparkling wine, chilled

Garnish:

Blood orange slice or dehydrated lemon slice

1. Fill a highball or other tall serving glass two-thirds with ice or use a collins spear.

2. Add the gin, dry vermouth, aperitif, blue curaçao, and bitters to the glass.

3. Top with the sparkling wine.

4. Garnish with a blood orange slice or dehydrated lemon slice.

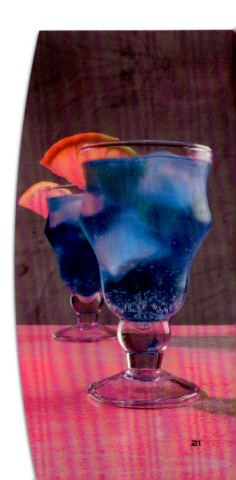

TUCHANKA SUNSET

Don't ever let anyone tell you that krogan don't have a sense of humor. I used to run with a Battlemaster in my early days whose wit was as dry and vast as an Asterian desert. We survived an Eclipse double-cross by the skin of our teeth, and when we got back to our dingy little hideout, he toasted our fortune with a Tuchanka Sunset. His own personal recipe. He claimed the bartenders at Afterlife know how to make it, if you ask. Now, I love a good sunset drink and as such was appalled to watch him dump black rum on top of an otherwise flawless concoction. Sensing my shock, with a wry half-smile he said, "Well, yeah, wouldn't be a sunset on Tuchanka without a choking cloud of toxic ash to ruin the view now, would it?"

◄ **SERVES:** 1 **ICE:** Collins spear ice or standard, 1-inch cubes **GLASS:** Collins or highball ►

½ ounce Tupo Concentrate (page 15) or grenadine

4 ounces pineapple juice

1 ounce Tuchanka Dry (page 11) (sub peanut butter or vanilla whiskey)

2 ounces black (or very dark) spiced rum

Garnish:

Luxardo or bourbon cherry

1. Add the Tupo Concentrate to the bottom of a highball glass.

2. Fill the glass two-thirds full with standard ice cubes or use a collins spear.

3. Add the pineapple juice and Tuchanka Dry to a cocktail shaker filled with ice.

4. Shake vigorously for 10 to 15 seconds until well chilled.

5. Strain the mixture slowly over the Tupo Concentrate to create a new layer.

6. Give the drink one slow stir to create a gradient effect.

7. Place a spoon on the surface of the drink and slowly pour the black spiced rum onto the spoon, letting it overflow. The rum should float on top of the drink, creating the final layer.

8. Garnish with a skewered cherry.

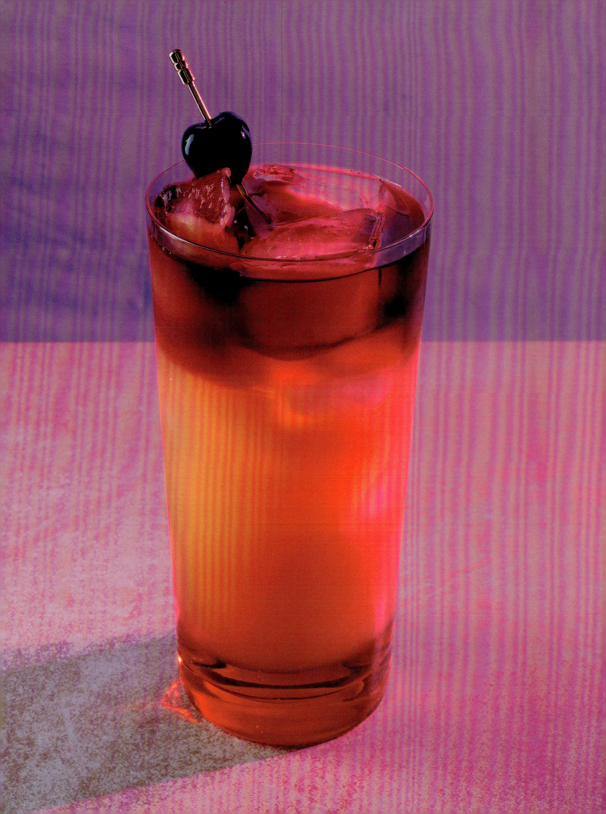

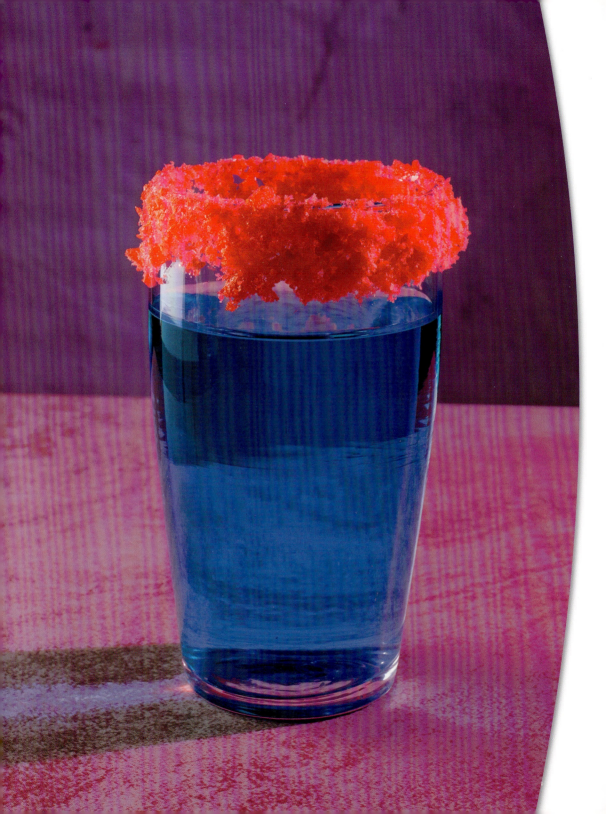

SERRICE ICE BRANDY

I find human Alliance officers to be particularly dull and single-minded. So new to space, with such a short lifespan, few know how to relax and have *fun*. Not so with their medical personnel: disgruntled, overworked, and with the romance of military life quickly snuffed out by the harsh realities of combat, they know how to put the Rs in R & R. Serrice Ice Brandy always reminds me of a particular Alliance doctor named Karin Chakwas, very posh and put together, who got a little salty after a drink (or several) of the stuff.

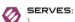 **SERVES:**
1

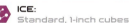 **ICE:**
Standard, 1-inch cubes

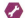 **GLASS:**
Lowball or rocks

2½ ounces pisco

½ ounce Simple Syrup (page 13)

½ ounce blue curaçao

¼ ounce pear brandy (optional)

¼ ounce lemon juice

2 to 3 dashes orange or other fruity bitters

Garnish:

Red cocktail or sanding sugar (for the rim)

Lemon juice, simple syrup or water (for the rim)

1. Spread the red sugar around in a shallow bowl.

2. In a separate shallow bowl, add enough lemon juice, simple syrup, or water to just cover the bottom of the bowl.

3. Dip the rim of a serving glass in the lemon juice, syrup, or water. Place the glass upside down in the sanding sugar and rotate so the sugar sticks to the rim.

4. Add the drink ingredients to a cocktail shaker filled with ice.

5. Shake vigorously for 10 to 15 seconds until well chilled.

6. Strain into the serving glass and add standard ice cubes to fill.

SOVAK JUICE

Have you heard the one about how krogan males name their infants? According to salarian scientist Padok Wiks, they get drunk on sovak juice and hold belching contests. Apparently, whatever sounds most like a word becomes a name. I doubt there's much validity to this claim (although . . . Wrex?) but I still remember the young krogan merc I renamed after a night of tossing back these nutty, bubbly little things together. It's been a while, but I do sincerely hope Urp is doing well out there.

 SERVES: 2

 ICE: Only for the shaker, but chill the glasses!

 GLASS: Seidel or pint, chilled

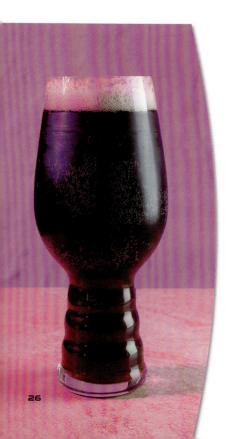

4 ounces Tuchanka Dry (page 11) (sub peanut butter or bacon whiskey)

1 ounce fresh lemon juice

1 ounce Simple Syrup (page 13)

6 to 8 dashes of chocolate bitters

24 ounces bock or dark lager (chilled)

Garnish:

For sovak juice? Come on, now.

1. Fill a cocktail shaker with standard ice.

2. Add the Tuchanka Dry, lemon juice, simple syrup, and chocolate bitters to the cocktail shaker. Shake well.

3. Strain into two chilled serving glasses.

4. Top each glass with chilled dark lager.

NOVERIAN RUM SWIZZLE

Seeing as rum is a liquor made with sugarcane molasses or sugarcane juice, one might associate it with warm, tropical climates. One would also be wrong and very much missing out on one of the finest varieties in the entire galaxy. I refuse to make this drink with anything less than quality Noverian rum (and Asari Honey Syrup, of course). Once you've had a taste, you'll understand why Aria T'Loak was so sulky after Purgatory's stock of the stuff ran out. Though, to be fair, having her entire empire occupied by Cerberus General Oleg Petrovsky may have also contributed to her sour mood. For that authentic touch of frost, I recommend harnessing biotics to give your stick the right amount of swizzle.

 SERVES: 1 **ICE:** Crushed **GLASS:** Zombie, collins, or highball

2½ ounces demerara rum (or other dark aged rum)

1 ounce Asari Honey Syrup (page 17)

2 ounces apricot nectar or mango juice

½ ounce lime juice

1 or 2 dashes rhubarb bitters (optional)

3 to 5 dashes aromatic bitters

Garnish:

Blue maraschino cherries

Cinnamon stick

1. Fill a collins glass three-quarters full with crushed ice. Add the rum, syrup, juices, and rhubarb bitters.

2. Hold a swizzle stick (or use a barspoon or a straw) in between your palms, then spin the shaft to churn the mixture until the drink froths and the glass becomes frosty.

3. Top with more crushed ice to fill and add a few dashes of aromatic bitters on top.

4. Garnish with maraschino cherries and a cinnamon stick.

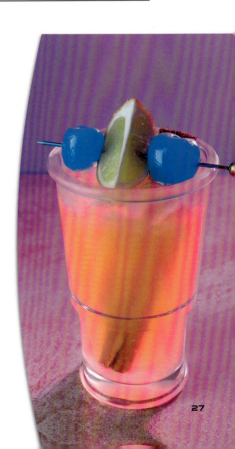

DARK STAR LOUNGE

Dark stars, as a theoretical curiosity, could be extremely powerful. Dark Star Lounge, an actual bar, definitively serves extremely powerful drinks. Located on the Citadel one level up from the C-Sec office in Zakera Ward (a convenient perp walk away when patrons get too rowdy), many bartenders are happy to give customers exactly what they ask for . . . the "usual" being a thumping hangover.

If you like your drinks stiffer than a turian's carapace, you've flipped to the right section. Higher-proof spirits with a higher spirit-to-mixer ratio for a higher class of drinker, Dark Star recipes do not disappoint. I trust you can handle it . . . and if you happen to wake up next to an attractive stranger the next morning whose name you can't quite recall, I recommend breaking the ice over some Huevos Rancheros à la Vega (see page 112, you charmer).

BATARIAN ALE SHANDY

If you're not a krogan or batarian, please don't drink uncut batarian ale. It's mean, it's green, and it will leave your insides clean. Instead, use this recipe to make yourself a refreshing and fizzy shandy. Yes, a human Spectre managed to stay on their feet after chugging a glass of the uncut ale—at least that's what one Dark Star Lounge bartender claims. But ask yourself: Are you really the type? I'm reminded of a naive bar patron cosplaying in plastic N7 armor he convinced his poor wife to buy him (along with his shuttle-fare off world, understandably). You're not "truly extreme." Do yourself a favor: Check your ego and enjoy the Batarian Ale Shandy.

 SERVES: 2 **ICE:** Standard, 1-inch cubes (optional) **GLASS:** Pint or pilsner (chilled)

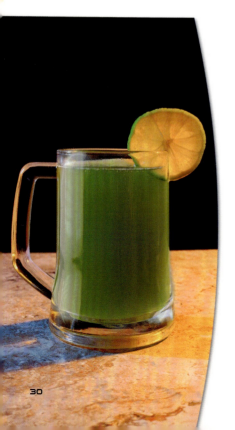

2 ounces high-proof bourbon

4 ounces sour apple schnapps (green)

4 ounces light sour beer or Gose, chilled

4 ounces sparkling apple cider, chilled

Garnish:

Lime wheel

1. Chill two beer glasses in the freezer for 10 to 15 minutes.

2. Add the bourbon and sour apple schnapps to the chilled beer glasses.

3. Add the beer and top with sparkling apple cider. Give it one gentle stir.

4. Add ice, to fill, if desired. Garnish with a lime wheel.

DARK STAR VESPERTINI

No trip to Dark Star Lounge is complete without ordering this signature cocktail, the Dark Star Vespertini, especially if you have a bit of a sweet tooth. I've included the recipe here, at great risk to certain of my … relationships … at the lounge. It's simply too delicious not to share, with a rich chocolate–raspberry taste. Be sure to shake this one well—for the nonbiotics who need to do this task manually, I liken it to the amount of time until you start to worry your arm will fall off. If it feels like you're giving the tumbler a quick ride in an M35 Mako, you're doing it right.

 SERVES: 2 **ICE:** Standard, 1-inch cubes for the shaker only **GLASS:** Martini or cocktail

1½ ounces London Dry gin

1 ounce Blue Thessia (page 10)

1½ ounces black raspberry liqueur

½ ounce Simple Syrup (page 13)

4 to 5 dashes chocolate bitters

½ ounce fresh lemon juice

Garnish:
Luxardo or bourbon cherry

1. Fill a cocktail shaker with ice.

2. Add the gin, Blue Thessia, raspberry liqueur, simple syrup, bitters, and lemon juice to the cocktail shaker.

3. Shake well.

4. Strain into a chilled martini glass.

5. Garnish with a speared black cherry.

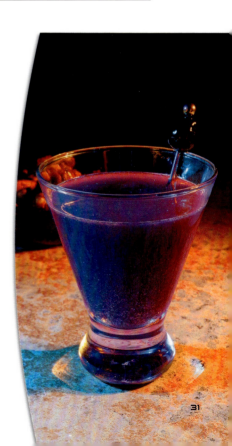

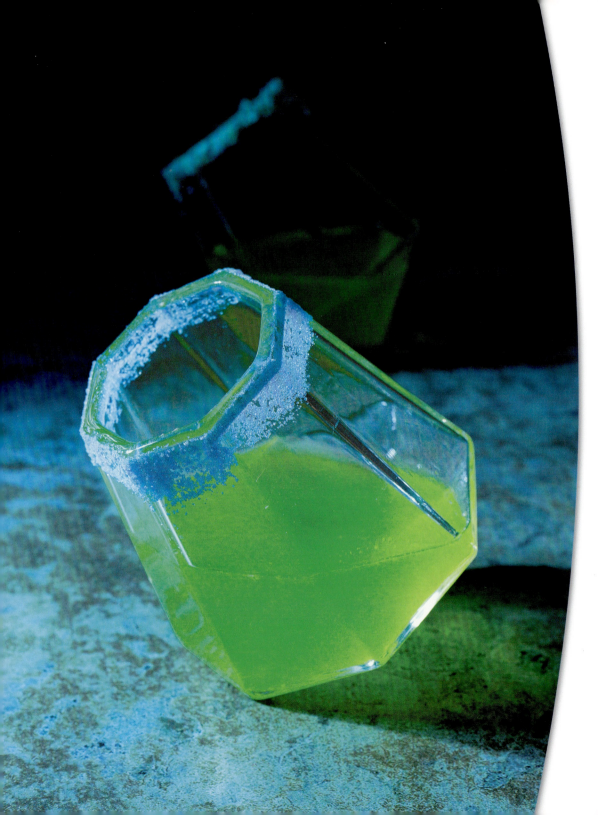

RYNCOL COCKTAIL

Listen up, tough guys. I promise you that bartenders are never impressed when you swagger up and ask for "the strongest you have." In fact, just to make sure you embarrass yourself in front of your friends, they'll probably slap on a fake smile and pour you a tall glass of krogan ryncol. Never heard of it? They certainly don't advertise the stuff. But for fun, let's spitball some potential slogans: "Ryncol! It hits aliens like ground glass," or "Ryncol! It's like sipping knives," or "Ryncol! It'll set off radiological alarms." Just ask a certain Commander Shepard. And enjoy your purple prayers to the porcelain goddess . . .

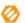 **SERVES:**
1

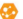 **ICE:**
Standard, 1-inch cubes

 GLASS:
Lowball or rocks

2 ounces high-proof vodka (100 proof)

1½ ounces melon liqueur

½ ounce blue curaçao

½ ounce lime juice

1 or 2 drops Salarian Salination Solution (page 14)

2 to 3 dashes orange bitters (optional)

Garnish:

Blue popping candy or blue sanding sugar (for the rim)

Corn syrup or honey (for the rim)

1. Spread the popping candy or sanding sugar around in a shallow bowl.

2. Dip the rim of a cocktail glass in syrup or honey. Place the glass upside down in the sanding sugar and rotate so the sugar sticks to the rim. Add ice to the glass and set aside.

3. Add the vodka, melon liqueur, blue curaçao, lime juice, saline, and bitters to a cocktail shaker filled with ice. Shake well.

4. Strain the mixture into the blue-rimmed cocktail glass.

PARAGADE PUNCH

While Tupari sports drinks are all the rage, don't discount Paragade! Especially in cocktails. By itself, it's not too good and it's not too bad, but mixed with alcohol, it's somewhat of a revelation. This recipe gives you a layered drink that starts out sweetly and ends with a real kick to the quads. Perfect for those nights where you might hold your tongue at one bar only to start throwing chairs at the next. It takes a deft hand to get the blue–purple–red proportions right when you're making one, and to get the ending you want after a night of drinking them.

 SERVES:
1

 ICE: Collins spear ice or standard, 1-inch cubes

 GLASS:
Highball

¾ ounce grenadine

3 to 4 dashes aromatic bitters

2 to 3 ounces blue sports drink of your choice

2 ounces vodka

½ ounce blue curaçao

1 or 2 drops Salarian Salination Solution (page 14)

Garnish:

Orange peel

Star anise

1. Use a sharp knife to cut the orange peel into the shape of a wing. Pin the star anise to the orange peel wing using a cocktail skewer. Set aside.

2. Add the grenadine and bitters to a tall glass, stir, then fill the glass with standard ice cubes or a collins spear.

3. Fill a cocktail shaker with ice and add the sports drink, vodka, blue curaçao, and saline.

4. Shake for 10 to 15 seconds until well chilled, then strain into the serving glass.

5. Give the drink a slow stir to achieve red, purple, and blue blended layers.

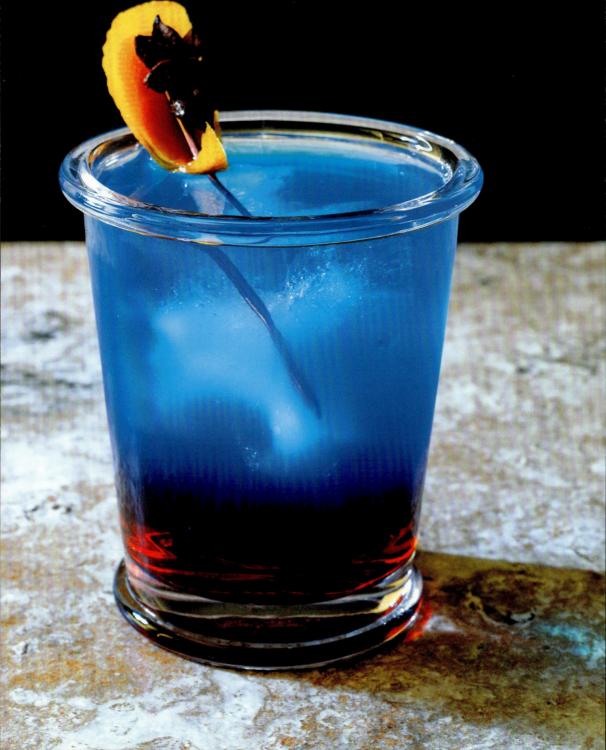

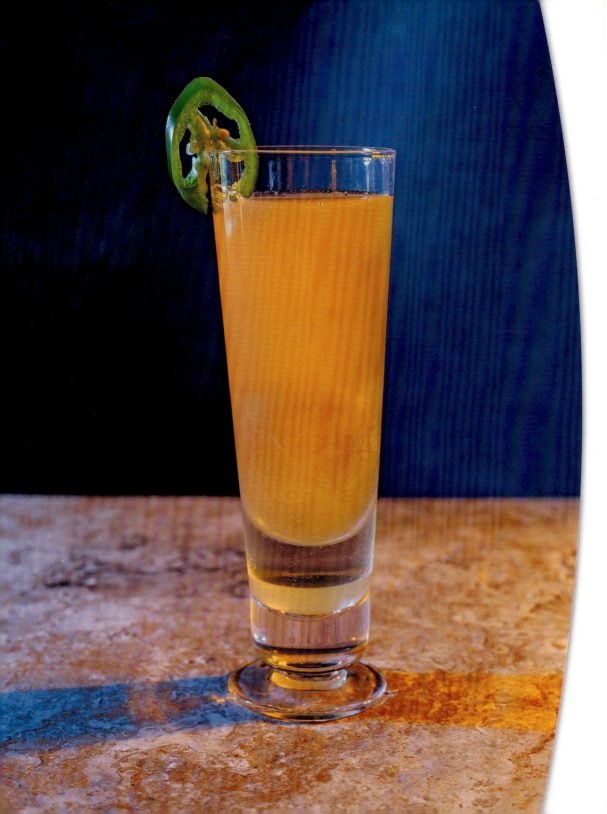

DEXTRO HEAT SINK

Like a boilermaker, the Dextro Heat Sink is a great way of making strong alcohol stronger. During his Archangel days, Garrus Vakarian and his crew would slug these like candy as they racked up wins against the Blue Suns, Blood Pack, and Eclipse thugs on Omega. This is a sweet and spicy tequila cocktail (the "heat") with a dropped shot of Ancho Reyes liqueur (the "sink"). An unlimited amount of these might be fun at first, with the occasional pause to blow some heat off your tongue, but it's advised to keep them to a finite amount.

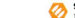 **SERVES:**
1

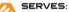 **ICE:**
Standard, 1-inch cubes

 GLASS:
Pint and shot

2 to 4 slices fresh jalapeño

1 ounce tequila

1 ounce mezcal

2 ounces pineapple juice, chilled

1 or 2 drops Salarian Salination Solution (page 14)

½ ounce lime juice

2 to 3 ounces spicy ginger beer, chilled

1 shot (1.5 ounces) Ancho Reyes liqueur

Garnish:
1 jalapeño slice

1. Place 2 to 4 slices of jalapeño in the bottom of a cocktail shaker. Use a muddler or the top of a wooden spoon to muddle the jalapeño.

2. Fill the cocktail shaker with ice.

3. Add the tequila, mezcal, pineapple juice, saline, and lime juice to the shaker.

4. Shake for 10 to 15 seconds until well chilled.

5. Strain into a pint glass and top with ginger beer. Garnish with an additional jalapeño slice.

6. Pour the Ancho Reyes into a shot glass and drop it into the pint glass before serving.

7. Add standard ice cubes, if desired.

TURIAN HOROSK

Considering the rigidity of turians, you'd need a pretty strong drink to loosen them up enough to get the wedgie out of their thermal armor. Enter: Turian Horosk. Another Garrus Vakarian favorite, you're not going to find this outside of a handful of bars, certainly not at the posher Silver Coast Casinos of the 'verse. So, if you're looking to calibrate your soberness in the opposite direction, here's the recipe for you. The lemonade flavor helps it go down easy and the spices are optional—the hangover from too many rounds of this, however, is not.

 SERVES: 1 **ICE:** Standard, 1-inch cubes **GLASS:** Tumbler

2 cups water

½ cup brown sugar

2 cinnamon sticks (optional)

2 whole cloves (optional)

2 whole allspice (optional)

½ cup 151- to 170-proof grain alcohol (such as moonshine)

Pinch sea salt

1 cup lemon and/or lime juice

Garnish:

Lemon wheel

Special Equipment:

Large pot

Whisk

2 mason jars or glass bottles with lids

1. In a large pot, heat the water, sugar to taste, and spices (if using) over medium heat. Simmer until the sugar has dissolved, whisking frequently.

2. Remove the pot from the heat and let the mixture cool.

3. Once the sugar–water mixture has cooled to room temperature, remove the spices and whisk in the alcohol, sea salt, and the lemon and/or lime juice.

4. Transfer to two mason jars or glass bottles with tight-fitting lids. Let it sit in the refrigerator for at least 2 days before drinking. Serve chilled over ice.

5. Store in the refrigerator for up to 2 weeks and in a freezer (after 2 days in the refrigerator) for up to 1 month.

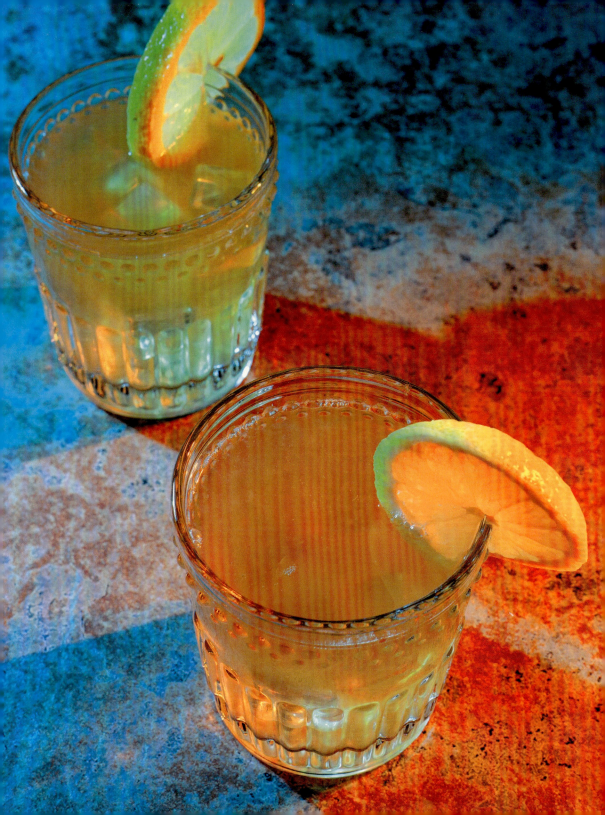

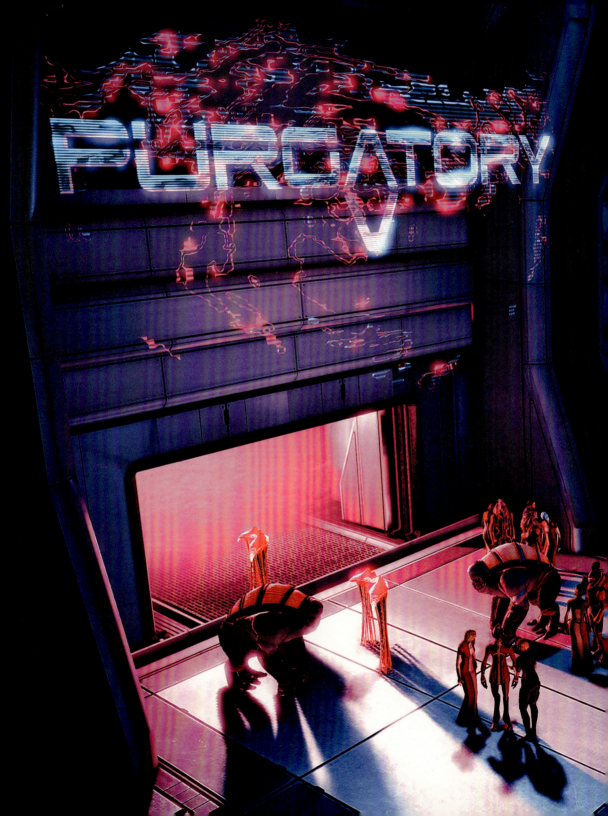

PURGATORY BAR

The Citadel is a tourist trap. Humans tend to view this as a disparaging label, but I say it with great enthusiasm. For my credits, there's no better way to take in the sights than as a lowercase t tourist, and there's no better place to do that than the Citadel. If you have the time, a bar named Purgatory serves drinks that are especially heavenly. If you like new takes on classic cocktails with a slightly higher mixer-to-alcohol ratio, sip on these before taking in the sights and sounds of the Presidium. And if you're just not convinced it's worth the visit, well, at least you can whip up these drinks at home.

And do take your Citadel recommendations with a grain of salt when you're there (barring the guide currently in your hands, of course). Especially ones coming from the hotshot human Spectre making the rounds—that one will endorse anything for a discount.

FROZEN PYJAK

The best part about tending bar? The customers. I learn a little about a lot just by listening. The worst part about tending bar? The customers. Sometimes I don't have to listen too intently, as their volume increases with their alcohol intake. For fun, I used to give my loudest customers a freebie: the Frozen Pyjak. I overheard Samantha Traynor boasting (loudly, ironically) about this and it sounded too entertaining not to try it out: Every few hours, you empty your spill pad into a martini glass and toss a little ice in for presentation. This is a much nicer variation for you to make. All these ingredients go incredibly well together, so you can serve it to people you actually like.

 SERVES: 1 **ICE:** Standard, 1-inch cubes (and/or 1 large) 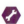 **GLASS:** Martini or cocktail

½ ounce London Dry gin

½ ounce white rum

½ ounce vodka

½ ounce silver tequila

½ ounce peach schnapps

½ ounce maraschino liqueur

½ ounce blue curaçao

½ ounce lime juice

1 ounce sour mix

Garnish:
Well now, that would defeat the point.

1. Add the ingredients to a cocktail shaker filled with ice.

2. Shake for 10 to 15 seconds until well chilled.

3. Strain into the martini glass.

4. Add standard ice cubes or one large piece of ice to fill the glass.

FULL BIOTIC KICK

My curiosity for the Full Biotic Kick was piqued by a charming young Alliance comms specialist named Samantha Traynor who extolled its virtues. Apparently, this was the most popular drink served when she worked "extensively" as a bartender during her university days . . . for a whole *four years*. I understand humans consider this quite the span of time—how quaint. I believe the "kick" comes directly from the Tuchanka Dry, and if you've ever faced down a biotic krogan Battlemaster (and lived to tell about it), you'll understand why.

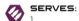 **SERVES:** 1 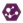 **ICE:** Collins spear ice or standard, 1-inch cubes 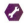 **GLASS:** Collins or highball

1 ounce bourbon

1½ ounces Tuchanka Dry (page 11) (sub peanut butter, bacon, or vanilla whiskey)

3 to 4 dashes orange bitters (optional)

3 to 4 ounces chilled ginger beer (to fill)

Garnish:
Orange twist

1. Add the bourbon, Tuchanka Dry, and orange bitters to a collins glass filled two-thirds full with standard ice cubes or a collins spear.

2. Add the ginger beer to fill.

3. Give the drink a quick stir.

4. Garnish with an orange twist.

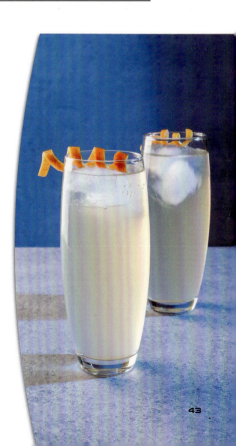

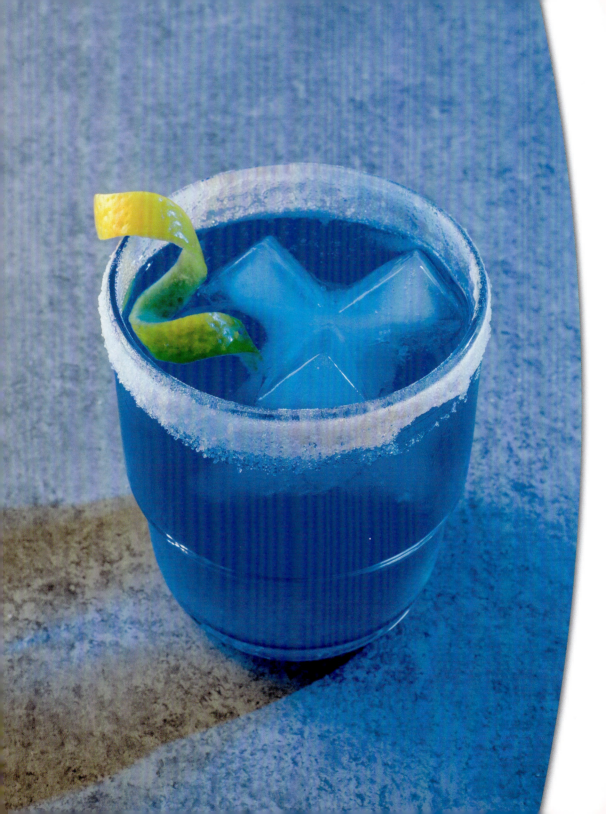

VODKA SKYCAR

As the Citadel became increasingly populated and its denizens spread across the wards of this colossal space station, they began to rely more and more on a centralized mode of transportation. Enter the skycar, a maddeningly slow shuttle that, though nowhere near as glacially paced as Citadel elevators, redeems itself with some of the most incredible views in the galaxy. When I need to slow down, I make myself a nice Vodka Skycar, get lost in its pretty sky-blue color, and hire an ambling ride around the glittering Citadel Tower. Magical.

 SERVES: 1 **ICE:** Only for the cocktail shaker **GLASS:** Martini or coupe

2½ ounces citron vodka

½ ounce blue curaçao

1 ounce lemon juice

¾ ounce Simple Syrup (page 13)

1 or 2 drops Salarian Salination Solution (page 14)

2 to 3 dashes orange bitters

Garnish:

Granulated sugar

Lemon twist

1. Spread the sugar around in a shallow small bowl. In a separate small bowl, add just enough lemon juice or water to cover the bottom.

2. Dip the rim of a cocktail glass in the lemon juice or water. Place the glass upside down in the sugar and rotate so the sugar sticks to the rim.

3. Add the drink ingredients to a cocktail shaker filled with standard ice cubes.

4. Shake for 10 to 15 seconds until well chilled.

5. Strain into the sugar-rimmed cocktail glass and garnish with the lemon twist.

ROJO LOCO

Everyone loves a good Rojo Loco: C-Sec, pirates, accountants, politicians, hunky Alliance marines who think pull-up contests and cute little nicknames might get you into their beds (full disclosure, they can, and they have . . . cheers, James Vega). Because underneath all the stories everyone tells themselves about themselves, at the end of the day, all any of us are really looking for is to enjoy a bit of spice and heat. Maybe that's a firefight. Maybe that's filing paperwork. Either way, this drink ticks that box and gives you the same warm tingle.

 SERVES:
1

ICE:
Standard, 1-inch cubes

 GLASS:
Margarita

1 or 2 slices habanero pepper (optional)

2 ounces tequila

2 ounces watermelon juice

1 ounce hibiscus tea

½ ounce lime juice

½ ounce agave or Simple Syrup (page 13)

1 or 2 drops Salarian Salination Solution (page 14)

Garnish:

Tajin (for the rim)

Corn syrup or honey (for the rim)

1 small watermelon slice

1. Add the tajin to a shallow bowl (just enough to cover the bottom).

2. In a separate shallow bowl, add the corn syrup or honey.

3. Dip the glass into the bowl of corn syrup or honey, then rotate the rim of the glass in the bowl of tajin to coat.

4. Muddle the sliced habanero in the bottom of the cocktail shaker, then add ice.

5. Add the tequila, watermelon juice, hibiscus tea, lime juice, agave, and salination solution to the cocktail shaker.

6. Shake for 10 to 15 seconds until well chilled.

7. Strain into the serving glass. Add ice to fill.

8. Garnish with a small slice of watermelon.

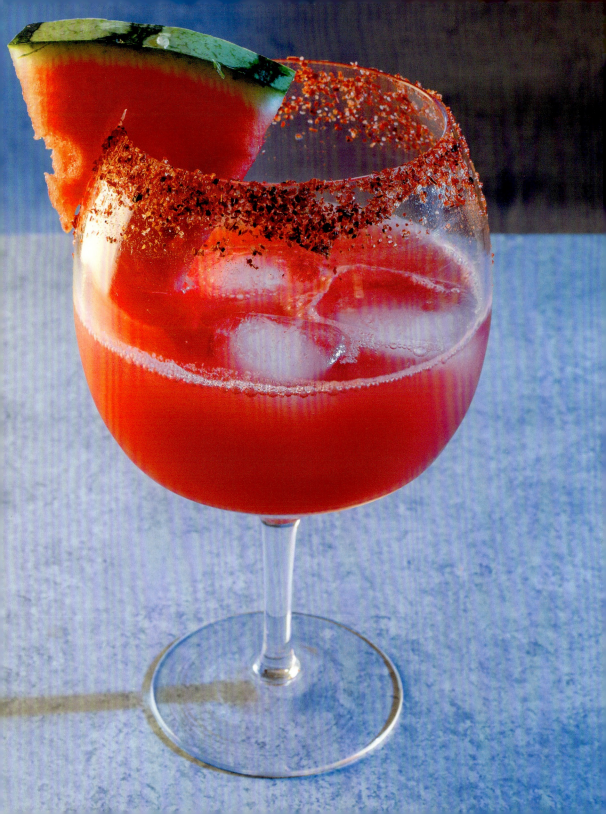

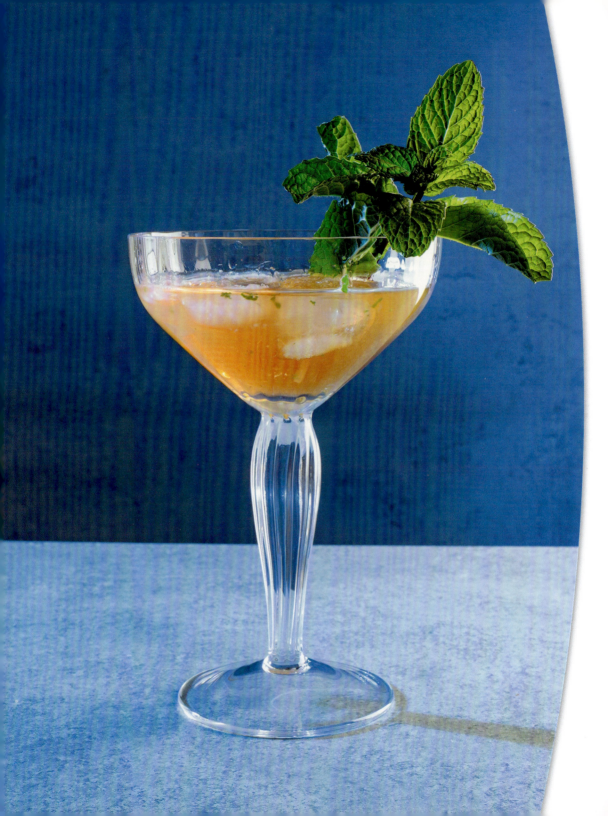

TM88 SMASH

I love a good rebrand. TM88 used to be known as "Merc's Courage," because drinking enough of the stuff gave one the false sense of strength that often comes with getting absolutely hammered. Salarians especially took a shine to this Earth-based whiskey and swore it had medicinal properties . . . when really it was the shortest distance between two points to get a person drunk. Ever the opportunists, salarians branded TM88 as a cure-all and "the only alcoholic drink endorsed by the Medical Board of Sur'Kesh." Alliance officer Kaidan Alenko credits the stuff for his speedy discharge from Huerta Memorial Hospital. So, drink up! Doctor's orders.

◄ **SERVES:**
1

 ICE: Crushed (plus standard, 1-inch cubes for shaker)

 GLASS:
Rocks or cocktail ►

8 to 10 fresh mint leaves

2 ounces black Andean whiskey or bourbon

¼ ounce lime juice

1 ounce Simple Syrup [page 13]

1 drop Salarian Salination Solution [page 14] [optional]

1 to 3 dashes Peychaud's bitters

4 to 5 dashes aromatic bitters

Garnish:

Mint sprig

1. Add the mint leaves to a cocktail shaker. Use a muddler or the back of a wooden spoon to muddle the mint.

2. Fill the cocktail shaker with standard ice cubes.

3. Add the Andean whiskey or bourbon, lime juice, simple syrup, salination solution, and bitters to the shaker. Shake well.

4. Strain into a rocks glass filled to the top with crushed ice and garnish with a mint sprig.

ETERNITY

Due to its extreme opulence and high level of security, the asari-run planet of Illium is a preferred tourist destination and (second, third, fourth) home of many of the galaxy's most well-known celebrities. It's also under a state of near-total surveillance. You can take their self-congratulatory media touting Eternity as "the sexiest bar in the Milky Way" with a few handfuls of salt (though with Matriarch Aethyta slinging drinks, "sexiest bartender" would be harder to argue with), but don't sleep on their drink selection.

I have a soft spot for asari drinks, as you might expect. I find them to be sweet and mellow and think Eternity gets them right. I've collected a few of my favorites for you here. Regarding the Liquified Turian (page 57) backstory, well . . . who can say if that one's legit? But seeing as the normally stringent customs laws of Council space on safety and sapient trafficking are relaxed on Illium, I can't say I'd be too surprised.

MYSTERY DRINK

I understand mystique. It's a powerful weapon that can influence your enemies before you ever need to fire a shot. I also understand bullshit and am very good at differentiating the latter from the former. So, when I first heard this Mystery Drink is rumored to come from "the deepest reaches of the Traverse," distilled on a "shadowy nameless planet" by "specifically adapted Vorcha," alarms were ringing in my head. Until I had a sip. Deceptively fruity and floral but highly intoxicating with an otherworldly appearance, well, does it matter where it came from, especially if you can get the same fabulous taste using syrup from canned lychees? No. In the case of this delicious little Mystery Drink, it most certainly does not.

 SERVES: 1 **ICE:** Only for the cocktail shaker 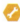 **GLASS:** Cocktail or lowball

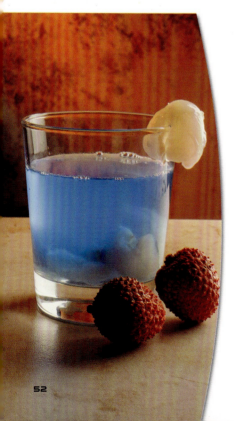

2 ounces navy-strength gin

1 ounce parfait d'amour

2 ounces lychee nectar or syrup

⅛ teaspoon rose water

½ ounce lime juice

Garnish:
2 or 3 lychees

1. Add the lychees to a cocktail glass.

2. Fill a cocktail shaker with ice. Add the gin, parfait d'amour, lychee nectar, rose water, and lime juice to the cocktail shaker and shake for 15 to 20 seconds until well chilled.

3. Strain into the cocktail glass.

ASARI HONEY-MEAD BELLINI

Made in an Ardat–Yakshi monastery, asari honey mead is for those with taste. And, let's be honest, credits. Whoever said "the best things in life are free" was compensating, because this expensive little drink is worth the experience. Ever the one to push boundaries, I prefer to prepare my honey mead with sparkling wine to make an effervescent little bellini, because the sweet and mellow flavor mixed with bubbles positively sparkles—in the glass and on the soul.

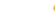 **SERVES:** 1 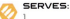 **ICE:** Only for the cocktail shaker 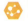 **GLASS:** Champagne flute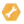

2 ounces mead, chilled

2 ounces peach purée, chilled

½ ounce elderflower liqueur

Pinch white or gold luster dust (optional)

2 to 3 ounces dry sparkling wine, chilled

Garnish:

Culinary-grade dried flower petals or fresh edible flower petals

1. Add the mead, peach purée, elderflower liqueur, and luster dust to a cocktail shaker filled with standard ice cubes.

2. Shake vigorously for 10 to 15 seconds until well chilled.

3. Strain into a champagne flute.

4. Top with sparkling wine.

5. Garnish with dried or fresh flower petals.

PERFECTION

I once crossed paths with this pretty little human who called herself Miranda Lawson. Despite her formidable intelligence, killer biotic abilities, and, well, let's just say her "superior physical constitution," she seemed to be ... missing something. She didn't say and I didn't press, but we shared a drink whose taste was as excellent as the woman pouring. Asking her what she called it, she gave a sad smile and simply said, "Perfection." Indeed. To her surprise (and delight, I might add), I sweetened the affair with a shot of strawberry liqueur and told her, "Yes, but there's always room for improvement, dear." Hmm. I wonder if she ever found what she was looking for.

 SERVES: 1

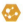 **ICE:** Only for the cocktail shaker

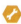 **GLASS:** Martini or coupe

2 ounces London Dry gin

1 ounce strawberry liqueur

¾ ounce elderflower liqueur

½ ounce fresh lemon juice

3 to 4 dashes aromatic bitters

Garnish:

1 strawberry slice or 1 small strawberry

1. Fill a cocktail shaker with standard ice cubes. Add the gin, strawberry liqueur, elderflower liqueur, lemon juice, and bitters.

2. Shake for 10 to 15 seconds until well chilled.

3. Strain into a martini glass.

4. Garnish with a whole strawberry or strawberry slices.

MEMORY STEALER

Ah, Kasumi Goto. The best thief in the business. You don't remember her and she prefers it that way. She's so good, she'll even nick your memory of her ever having been there . . . along with whatever valuables you had in your pockets. When I do have the good fortune of remembering her, I like to pour this drink made with Japanese gin in her honor. And like the master thief herself, one too many Memory Stealers will no doubt leave you with a hazy recollection the next morning.

◄ **SERVES:** 1 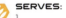 **ICE:** Only for the cocktail shaker **GLASS:** Cocktail or coupe ►

2 ounces Japanese gin (or use London Dry)

¾ ounce maraschino liqueur

¾ ounce yuzu or fresh lime juice

½ ounce orgeat syrup

3 to 4 dashes cherry or citrus bitters

Garnish:

1 citrus slice

1. Add the drink ingredients to a cocktail shaker filled with ice.

2. Shake for 10 to 15 seconds until well chilled.

3. Strain into a cocktail glass.

4. Garnish with a citrus slice.

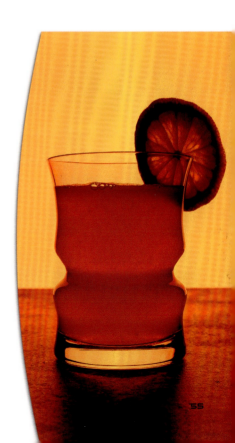

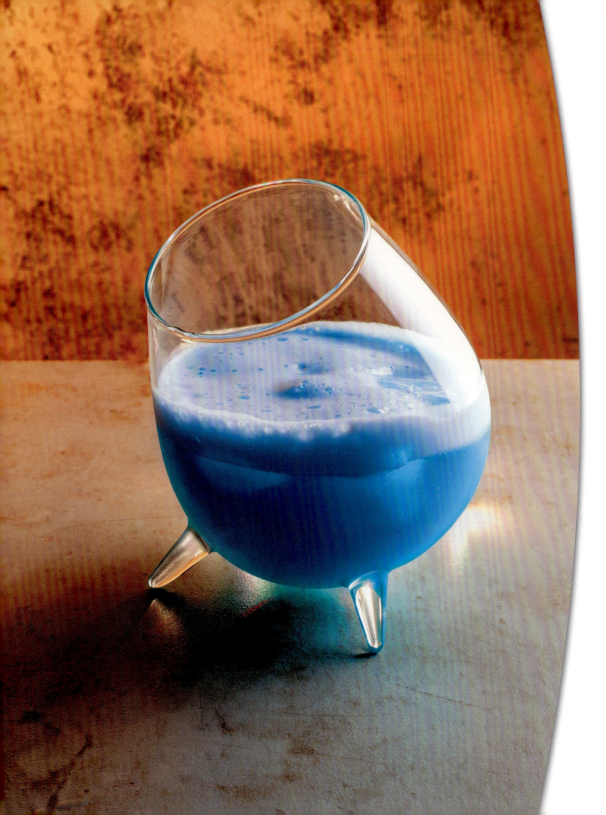

LIQUIFIED TURIAN

"Ambree," you say. "Certainly, Matriarch Aethyta's story of a krogan drinking liquefied turian on a bet is embellished? A tall tale? Urban legend meant to titillate, disgust, and delight?" Maybe. Regardless, it's one of my favorites, so I made this drink in homage (and to capitalize off the story—your girl is nothing if not quick to make a quick cred). I use a tequila base, with agave being native to a desert climate like you'd find on Palaven. Of course, I use egg white for the smooth texture, plus saline to stabilize this particular choice of "protein." And the blue curaçao, well, turian blood is blue, after all! Mm, you can almost taste the dextro-amino acids.

| | SERVES:
1 | ICE:
Standard, 1-inch cubes | GLASS:
Rocks | |

For the drink:

2 ounces silver tequila

¾ ounce blue curaçao

¾ ounce fresh lime juice

½ ounce falernum syrup

1 egg white (or 2 tablespoons aquafaba)

1 dash of Salarian Salination Solution (page 14)

Garnish:

No embellishment needed with a backstory this impressive.

1. In a cocktail shaker, dry shake all the ingredients together for 15 to 20 seconds.

2. Add ice to the cocktail shaker and shake vigorously for another 15 to 20 seconds.

3. Strain into a serving glass. Add ice to fill.

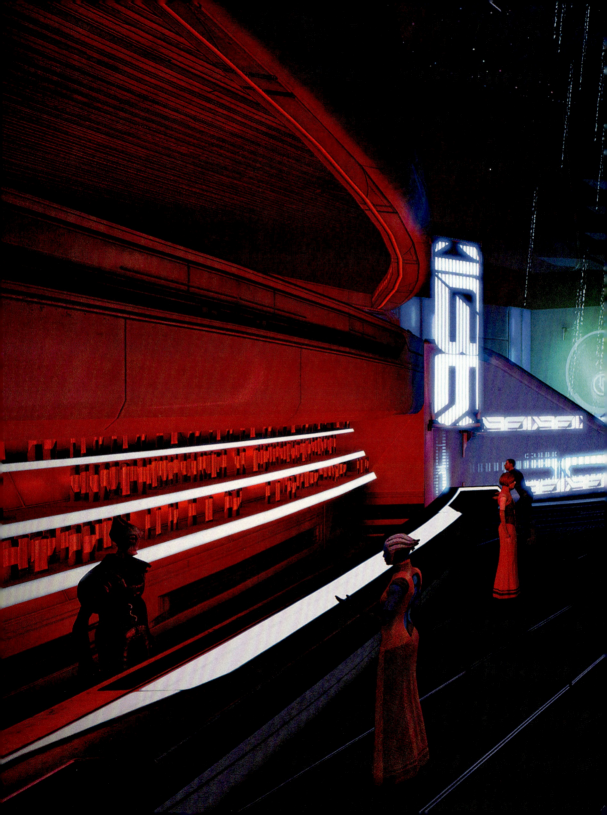

FLUX

Flux is one of the more recent night spots to open on the Citadel and boasts a casino in addition to a well-stocked bar. The atmosphere is almost as inviting as the volus who runs the place—alternating between owner, cook, and bartender, one wonders where Doran finds the energy. But at some point, you'll be sure to find this little macaroon from Irune shaking his pressure suit on the dance floor.

The recipes I've collected from Flux are, as you can imagine, fun and whimsical. Seeing as Doran spends an equal amount of time in the kitchen as he does behind the bar, you can also find a fair bit of culinary flare in the drink preparation. Enjoy yourself, Earth-clan!

TUPARI BLAST

Despite the volus being a race not cut out for physicality of any kind, their mastery of trade and commerce has helped Tupari sports drinks conquer the galaxy. It seems like you can't swing a dead CAT6 without hitting a vending machine of the stuff, and Doran has a particular fondness for it. I'd be remiss to not include it here, both for its delicious taste and because of how well it sells. Its strong fruity flavor makes it a consistent Flux favorite. It'll give you the courage to get on the dance floor and the electrolytes to stay there until closing time.

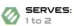 **SERVES:** 1 to 2

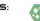 **ICE:** Crushed (plus standard, 1-inch cubes for the shaker)

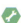 **GLASS:** Collins or highball

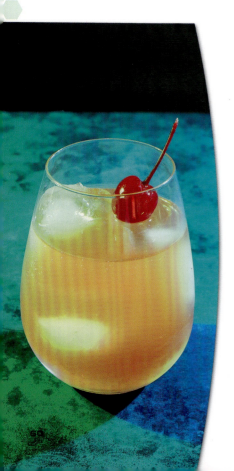

1½ ounces white rum

1 ounce coconut rum

½ ounce banana schnapps

½ ounce Tupo Concentrate (page 15)

2 to 3 ounces strawberry–banana sports drink (or sub strawberry–banana coconut water)

Garnish:
Maraschino cherry

1. Fill a collins or highball serving glass to the top with crushed ice.

2. Add everything to a cocktail shaker filled with ice.

3. Shake vigorously for 10 to 15 seconds until well chilled.

4. Strain into the serving glass.

RUM RELAY

A toast to the Mass Relays! Forgive my (brief, I promise) indulgence in sentimentality, but the Relays have brought together an array of intelligent life whose differences remind us of how we're all pretty much the same: unsure of our place in the universe, but in our best moments willing to teach and learn from our Milky Way sisters and brothers. No one understands that better than Doran, and what better way to celebrate it than by sloshing a Rum Relay milk punch all over the dance floor as you boogie the night away.

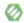 **SERVES:**
1

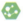 **ICE:**
Standard, 1-inch cubes

 GLASS:
Lowball or rocks

1 ounce dark rum

1 ounce Horse Choker (page 12) (sub equal parts spiced rum and coffee liqueur)

1 ounce brandy

3 to 4 ounces cream or half-and-half

½ ounce Asari Honey Syrup (page 17)

1 teaspoon vanilla extract

Garnish:
Roasted cinnamon and/or freshly grated nutmeg

Cinnamon stick

Star anise

1. Add the drink ingredients to a cocktail shaker filled with ice.

2. Shake for 15 to 20 seconds until well chilled and slightly frothy.

3. Pour into a rocks glass and add ice to fill.

4. Sprinkle with roasted cinnamon and/or freshly grated nutmeg.

5. Add a cinnamon stick and a star anise to garnish.

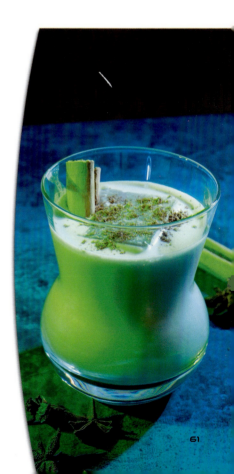

BLASTO STING

This one unironically *loves* the Blasto franchise. The acting, the writing, the backdrops? High camp, babe. A human essayist, Sontag, wrote, "You can't camp about something you don't take seriously. You're not making fun of it; you're making fun *out of it*." And what's more fun than adding cream to grape Pucker? It creates a hanar in every shot. Try my favorite drinking game: gather your friends, fire up *Blasto Saves Christmas*, and throw back a Blasto Sting every time he says, "Enkindle THIS!"

 SERVES:
1

 ICE:
None

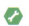 **GLASS:**
2-ounce shot

½ ounce sour grape schnapps or purple sour berry liqueur

¾ ounce vodka or white rum

½ ounce white (clear) crème de cacao

½ teaspoon white chocolate cream liqueur (opaque), cream, or half-and-half

Garnish:

Purple popping candy

Lemon juice

Special Equipment:

Liquid dropper

1. Spread the purple popping candy around in a shallow bowl. In a separate small bowl, add just enough lemon juice to cover the bottom.

2. Dip the rim of a 2-ounce shot glass into the bowl of lemon juice or water. Then place the glass upside down in the popping candy bowl and rotate so the purple pieces stick to the rim.

3. Add the sour grape schnapps to the shot glass.

4. Hold a spoon over the surface of the grape schnapps and slowly pour the vodka over the spoon so that it floats on top of the grape schnapps. Use the same spoon method to add the crème de cacao, which will sink and mix with the vodka.

5. Use a dropper to add a few drops of white chocolate cream liqueur on top of the drink. It will sink slightly and create a tentacle-like effect in the shot.

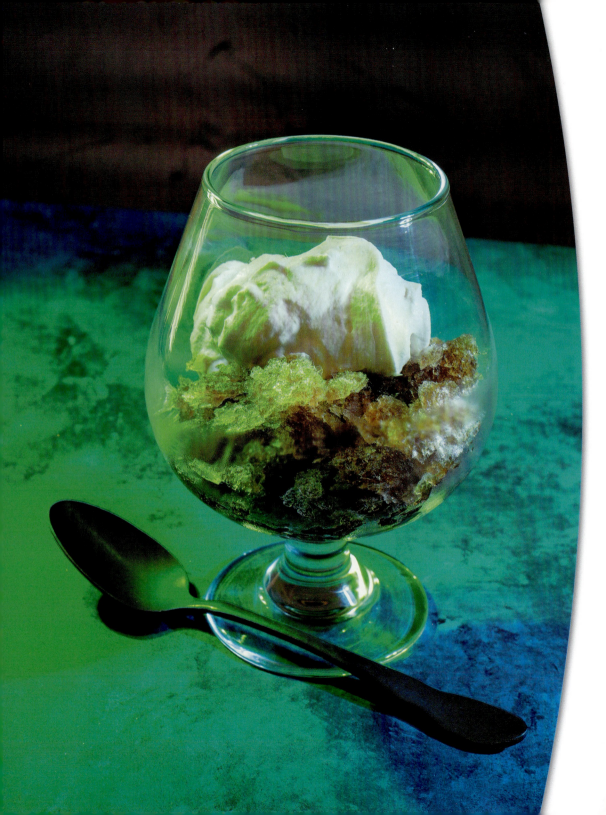

DENORIAN BEER GRANITA

Krogan are not known for negotiation. If you find yourself mediating with one, for goddess' sake do *not* show up empty-handed. I tried to bluff my way through just such a situation once and you wouldn't be reading this book if I hadn't had ingredients for Denorian Beer Granita on hand. I developed a fondness for Denorian beer from Urdnot Wrex, but this cocktail takes it to another level. In a desperate attempt to cool tensions, I offered to make a round of this unique drink with its smooth taste, fun texture, and visually appealing look. The krogan got the recipe and I got to walk away (with a little extra pep in my step from the caffeine). Win-win.

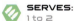 **SERVES:** 1 to 2 **ICE:** None **GLASS:** Fishbowl, wineglass, or dessert cup

For the granita:

4 ounces espresso or cold-brew coffee concentrate

2 tablespoons dark brown sugar

4 ounces stout beer

1 ounce Horse Choker (page 12) (or sub equal parts spiced rum and coffee liqueur)

For the topping:

1 ounce Irish cream

4 ounces heavy whipping cream, chilled

Special Equipment:

Small mixing bowl

Whisk

Freezer-safe pan

16-ounce glass jar with a lid

Stand mixer or hand mixer (optional)

1. In a small mixing bowl, add the espresso and brown sugar. Whisk until dissolved. Add the stout and Horse Choker, if using. Stir to combine.

2. Pour the mixture into a freezer-safe pan and freeze for 2 hours.

3. Take the container out and, with a fork or spoon, scrape the mixture into a slushy-like consistency. Place back in the fridge for another hour or two.

4. Take out the beer mixture and use a spoon or fork to scrape the mixture into ice shavings. Place back in the freezer for 1 hour or until serving time.

5. Place a 16-ounce glass jar with a lid in the freezer for 20 minutes. Pour the Irish cream and the chilled heavy cream into the jar and shake vigorously until a soft whipped cream forms, about 5 minutes. Alternatively, whip the cream in a stand mixer or in a mixing bowl with a hand mixer.

6. When ready to serve, scrape the surface of the beer slush into large, icy flakes. Spoon the granita into a serving glass. Top with a dollop of the whipped cream.

TASTY TANKARD

What can I say? I'm a Matriarch with a Maiden's tastes: I like a pretty young thing on my arm, a warm Acolyte pistol, and a heaping bowl of human ice cream. Chocolate, if you're taking notes. The Tasty Tankard is essentially a boozy milkshake, and I urge you to ignore anyone who tries to tell you that drinks made in a blender only belong in cheesy resorts. This one goes down dangerously easy, and the recipe makes enough for two . . . or one krogan with a sweet tooth. If that krogan happens to be Grunt, I advise having enough on hand to fill a large enough container. Perhaps a flower pot's worth?

 SERVES:
2 . . . or 1 krogan

 ICE:
None

 GLASS:
2 glass mugs or tankards

2 ounces Irish cream

1 ounce coconut rum

1 ounce butterscotch schnapps

2 scoops chocolate ice cream

6 to 8 ounces whole milk

Garnish:

Chocolate sauce

Whipped cream

Chocolate shavings

Special Equipment:

Blender

Knife or cheese grater

1. Holding a serving glass tilted at a 45° angle, gently squeeze the chocolate syrup around the interior sides, starting at the bottom and working your way up. Rotate the glass as you go to create a swirl pattern. Repeat with your second glass mug or tankard, if applicable. Set aside.

2. In a blender, add the Irish cream, coconut rum, schnapps, chocolate ice cream, and milk. Blend until smooth.

3. Pour the contents of the blender into the mug(s).

4. Top with whipped cream and use a knife or cheese grater on a chocolate bar to create the chocolate shavings on top.

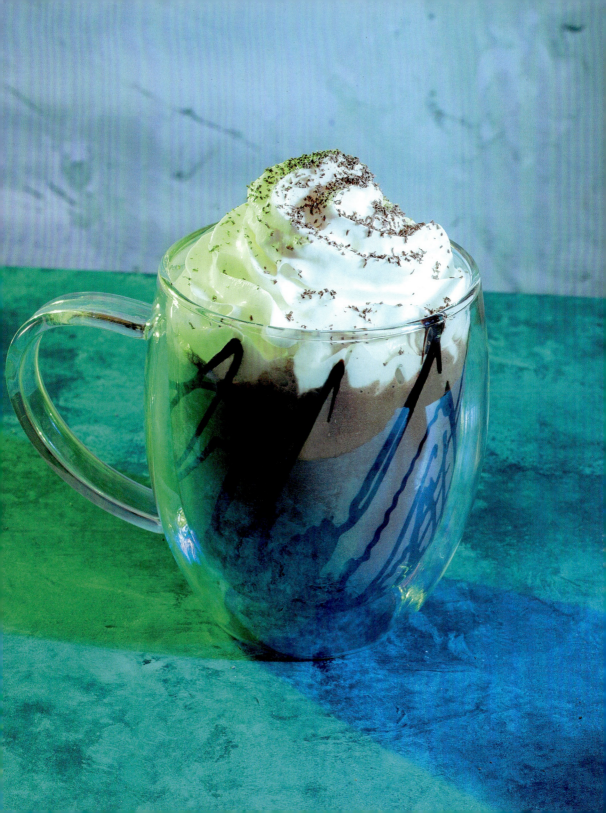

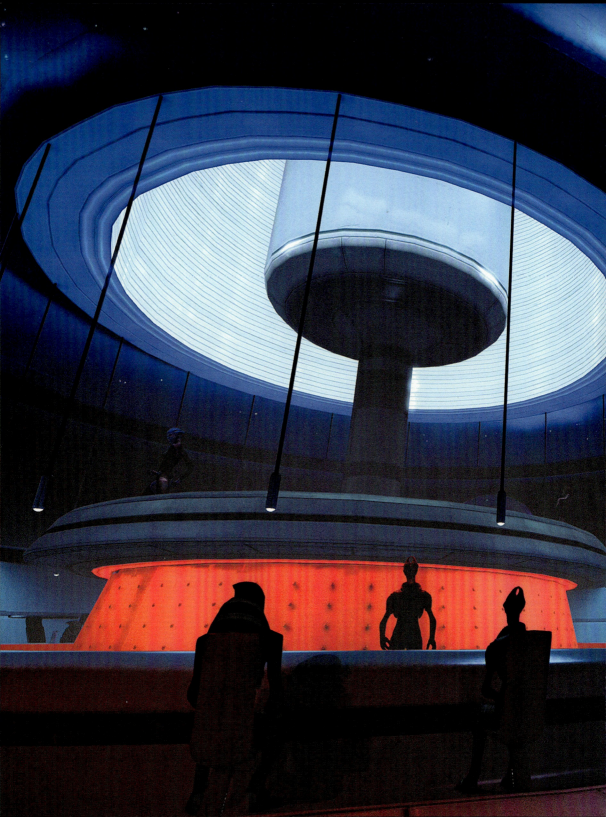

CHORA'S DEN

Not for the faint of heart, Chora's Den on the Citadel is the "livelier but deadlier" choice to stop for a drink. A gentleman's club owned by a scoundrel (novel, I know), the clientele and drinks lean heavily toward the strong and seedy type. The loud music and low lighting do well to cover the bloodstains and less-than-legitimate conversations, but you'll have a great time if you mind your business and tip the asari dancers well.

Be sure to ask Fist, the proprietor of this fine establishment, about the back room—it's perfect for your next shady deal. And I'm not one for gossip, but if you're curious about the smell, I've heard Fist has a habit of burying "old problems" under the dancers' stage. The following recipes evoke the Den's more . . . aggressive tendencies.

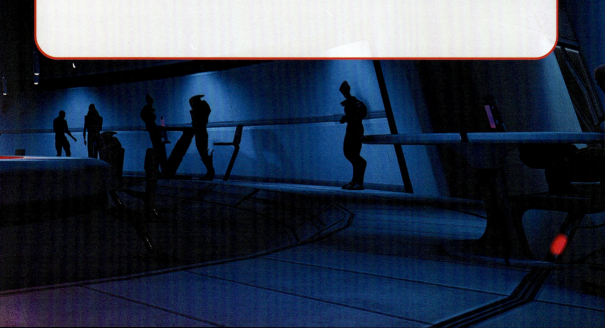

TEQUILA SE'LAI

Whether you're human, turian, or salarian, we've all got our shared little "catch phrases" we catch ourselves saying: "Embrace eternity" if you're asari, "Victory or death" if you're krogan, ★*heavy breathing intensifies*★, if you're volus . . . you get the idea. I quite like the quarians': "Keelah Se'lai," or "By the homeworld I hope to see one day." Tragic but beautiful. This recipe is an ode to their homeworld, Rannoch, with desert and coastal flavors all brought together with a lovely prickly pear syrup.

 SERVES: 1 **ICE:** Standard, 1-inch cubes 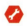 **GLASS:** Rocks

1½ ounce tequila

1 ounce prickly pear syrup (sub dragon fruit syrup or agave)

¼ ounce orange liqueur

½ ounce lime juice

2 to 3 ounces coconut water

Garnish:

1 lime wheel or dehydrated citrus slice

1. Add the drink ingredients to a cocktail shaker filled with ice.

2. Shake for 10 to 15 seconds until well chilled.

3. Strain into an ice-filled rocks glass.

4. Garnish with a lime wheel or dehydrated citrus slice.

ELASA

I'm not really a "drown your sorrows" type of gal. I'm more of the "drown you in a hail of incendiary ammo if you upset me" type. To each their own. If you lean more on a shoulder and less on a trigger, you can't go wrong with an Elasa, aka Sorrow's Companion. (They're not joking when they say it serves one . . .) Pale green with a bitter aftertaste and tangy sweetness, it's a great way to take life's lemons and make lemon garnish for your cocktail (or limes, in this case). Fist, ever putting the gentlemen in gentlemen's club, used to refer to this drink as The Cynthia, a snide reference to Elasa being Alliance Commander David Anderson's preferred drink during his divorce.

 SERVES:
1

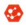 **ICE:**
Standard, 1-inch cubes

 GLASS:
Rocks

4 thick slices cucumber

2 ounces Plymouth or London Dry gin

1 ounce green chartreuse

¾ ounce Simple Syrup (page 13)

¼ ounce lime juice

2 ounces pisco

Garnish:

Lime wheel or cucumber slice

1. Muddle the cucumber in a cocktail shaker.

2. Fill the cocktail shaker with ice.

3. Add the gin, chartreuse, simple syrup, lime juice, and pisco.

4. Shake for 10 to 15 seconds until well chilled.

5. Strain into a rocks glass filled two-thirds with ice.

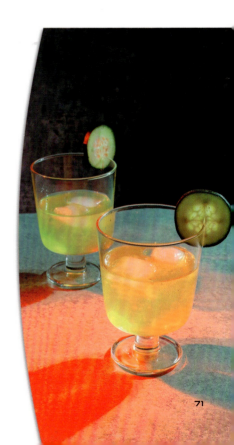

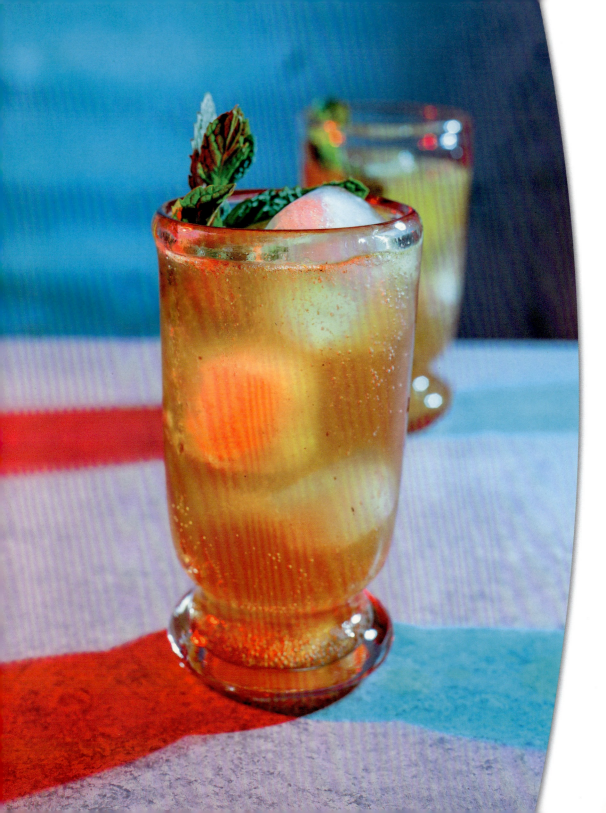

QUAD KICKER

Not for the faint of heart, the Quad Kicker will, well, kick you straight in the quad, I suppose. Samantha Traynor is adamant about "no curry powder" in her version, but why take away that spicy mouthfeel? Add that curry simple syrup and let this baby wake you up! It ain't called the Quad Fondler, so step up and throw down with your friends (or enemies).

 SERVES: 1 **ICE:** Collins spear or standard, 1-inch cubes **GLASS:** Collins, zombie, or highball

For the curry simple syrup:

½ cup water

½ cup brown sugar

1 tablespoon curry powder

For the drink:

½ ounce curry simple syrup (optional)

1 ounce spiced rum

1 ounce bourbon

½ ounce fresh lime juice (optional)

2 to 3 ounces ginger ale

Garnish:

Curry leaves or mint leaves

Special Equipment:

Small saucepan

Mason jar

1. If making the curry simple syrup, add all the syrup ingredients to a small saucepan and bring to a boil, stirring frequently. Lower the heat and simmer for 10 to 15 minutes. Remove from the heat and let cool to room temperature in a covered heat-resistant container, such as a mason jar.

2. Add a collins spear or standard ice to fill two-thirds of a tall glass like a collins or highball.

3. Add the bourbon, spiced rum, lime juice, and curry simple syrup to taste to a cocktail shaker filled with ice.

4. Shake for 10 to 15 seconds until well chilled. Strain into the serving glass.

5. Fill the serving glass with ginger ale.

6. Garnish with curry leaves before serving.

SHADOWBROKERTINI

I hope by this point you've come to realize that I know everything that's worth knowing. Yet I humbly admit that, try as I might, I'm still unable to unmask the Shadow Broker. But I am familiar with their agents, including a certain proprietor of Chora's Den. And even though Fist refuses to confess what he knows (which, I suspect, is even less than I do), he did agree to collaborate on a cocktail worthy of that confidential entity. Dark, shadowy, and with enough caffeine to help keep one sharp in the secrets-trading game, the Shadowbrokertini theatrically uses dry ice to add an air of mystery. I trust you don't need the Shadow Broker's services to know that swallowing dry ice can kill you, yes?

◄ **SERVES:** 1 **ICE:** Dry ice (optional), plus standard ice cubes for the shaker **GLASS:** Martini or coupe ►

1½ ounces vodka

1 ounce cold brew liqueur (or other coffee liqueur)

1 ounce black raspberry liqueur

½ ounce lime juice (optional)

Garnish:

Lime twist or lime slice

Special Equipment:

Tongs/protective gear

1. Chill a martini glass or coupe in the freezer for 10 to 15 minutes.

2. Add the vodka, coffee liqueur, raspberry liqueur, and lime juice to a cocktail shaker filled with ice.

3. Shake vigorously for 10 to 15 seconds until well chilled.

4. Strain into the chilled martini glass.

5. Using tongs or protective gear, drop in a small piece of dry ice and watch the effect, but make sure not to consume the dry ice. The dry ice is gone when the drink stops bubbling and smoking. It's not safe to drink before then.

6. Garnish with the lime twist or lime slice. (Note: Some Shadow Brokers prefer it without lime at all.)

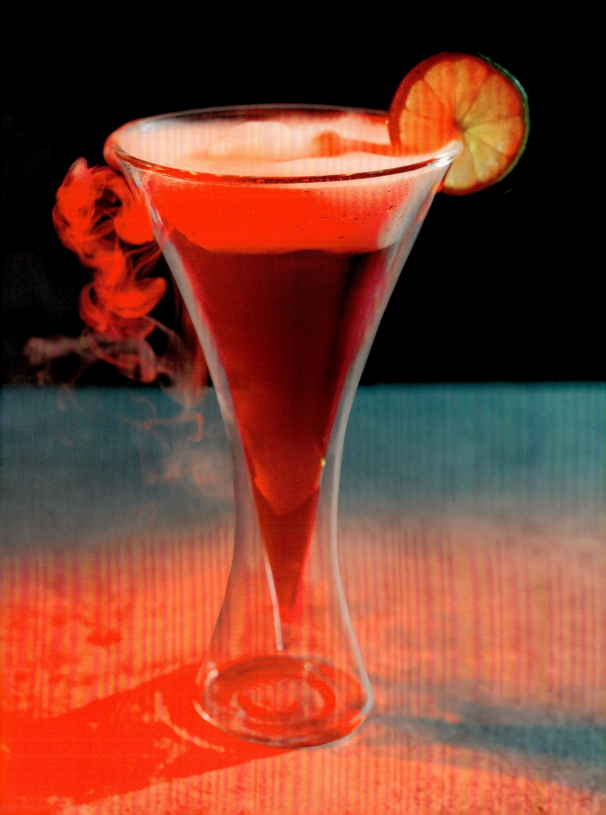

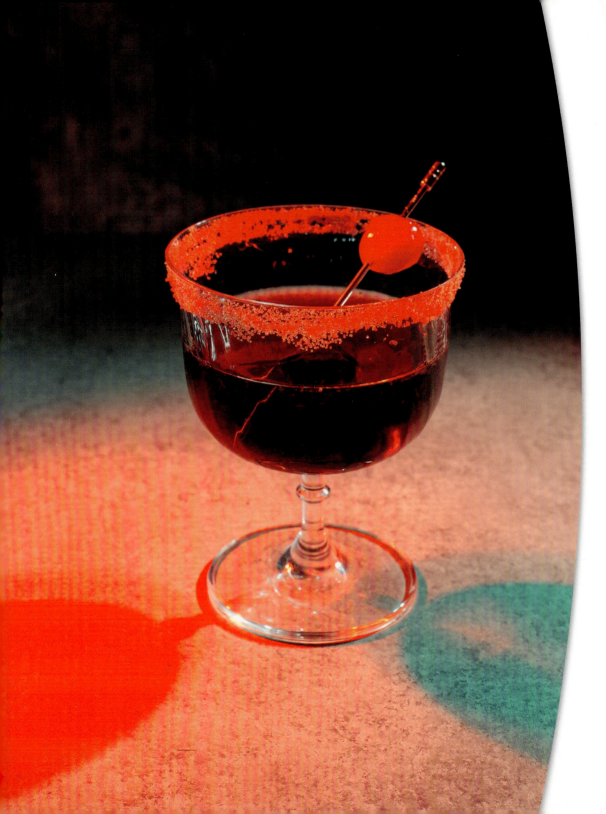

THE EROTIC BIOTIC

I suppose I should start this one off with a warning: Don't underestimate young asari. Yes, there is a strong drive for at the Maiden stage to explore and experience. Curious and restless, some look for the nearest bar to dance in. But that's no reason to let your guard down. Many don't realize their mistake until they're telekinetically slammed into the nearest concrete wall. Well, that's just the ratio of risk-to-reward that Chora's Den captures with this drink. With a winky flavor profile of fruit and cream, finish your Erotic Biotic with Drell Skin Venom to add a tingly bite (for the adventurous types), or with chocolate bitters (for the romantics). I like a bit of both—I may be a Matriarch, yet I've never lost that desire to explore and experience . . .

 SERVES: 1 **ICE:** For the cocktail shaker only **GLASS:** Coupe or martini

2 ounces whipped cream vodka

1½ ounce kinky pink or strawberry Pucker

½ ounce fresh lemon juice

½ ounce Blue Thessia (page 10)

6 to 8 drops Drell Skin Venom and/or chocolate bitters

Garnish:

Lemon juice

Purple sanding sugar

Maraschino cherry

1. Add just enough purple sanding sugar to cover the bottom of a small shallow bowl. In a separate small bowl, add just enough lemon juice or water to cover the bottom.

2. Dip the coupe glass first in the juice or water and then into the sugar and rotate to coat. Set the glass aside.

3. Add the drink ingredients to a cocktail shaker filled with ice.

4. Shake vigorously for 10 to 15 seconds until well chilled.

5. Strain into the sugar-rimmed glass.

6. Skewer a maraschino cherry with a cocktail skewer and drop it into the glass before serving.

THE SHIFTY COW

While I've heard just about every maxim in the 'verse, one rings particularly true: "You can't trust any animal that can milk itself." Yes, I'm talking about space cows, with their unsettling, grabby little hands. Turn your back around one and they'll pick through your pockets. The Shifty Cow cocktail is a clarified milk punch. And that's partly because it's fun to separate the milk solids from the drink, but also because I'm reminded of these audacious little cows eagerly separating an unsuspecting fool from their credits. And yes, we do have that in common, which reminds me of a human maxim: "Don't hate the player, hate the game." You win this round, space cows.

 SERVES:
2

 ICE:
2 large spheres

 GLASS:
Rocks or brandy snifters

4 ounces cognac or brandy

3 ounces lemon juice

1½ ounces pure maple syrup

4 to 5 dashes aromatic bitters

2 ounces sweet vermouth or port wine

3 ounces whole milk and/or cream, chilled

Garnish:

Pinch or ¼ teaspoon grated nutmeg

2 lemon peels

Special Equipment:

Glass jar with a lid or plastic wrap

Fine-mesh strainer or coffee filter

1. In a mixing glass, combine the cognac, lemon juice, maple syrup to taste, bitters, and sweet vermouth. Taste and adjust the sweetness level as needed.

2. In a glass jar, add the milk and/or cream.

3. Pour the cognac mixture into the milk mixture. You want to pour the cognac mixture into the milk and not the other way around. This will make it easier to filter later.

4. Give everything a quick stir before covering the jar with a lid or plastic wrap and transferring it to the refrigerator. Let this sit for at least 1 hour in the fridge, allowing the milk to curdle and separate.

5. Pour the mixture through a fine-mesh strainer, discarding the larger milk solids, then let it run through a coffee filter for 30 minutes and discard the smaller solids.

6. Optionally, strain once more with a new coffee filter for an ultra-clarified cocktail.

7. Pour into serving glasses with 1 large ice cube each. Garnish with grated nutmeg and a lemon peel.

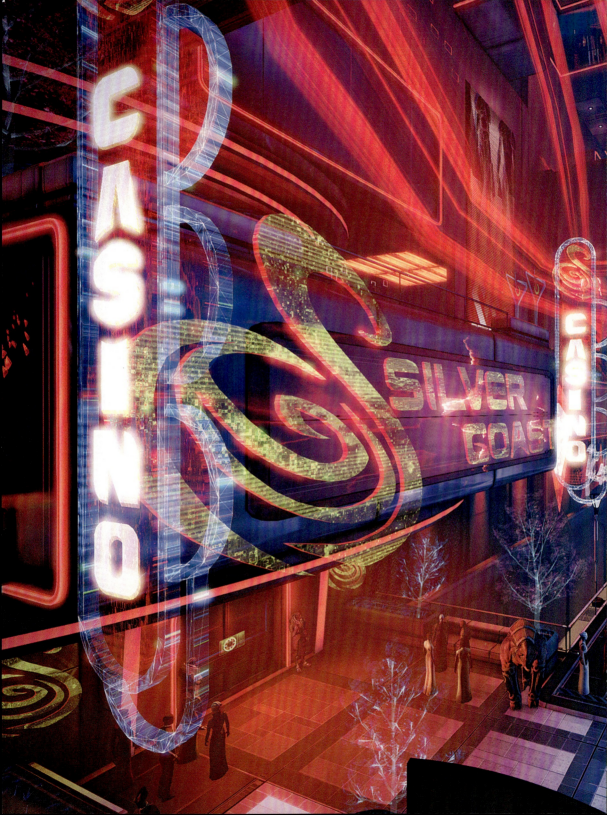

SILVER COAST CASINO

The Silversun Strip, with its glittering residences, combat-simulator complex, and electronic gaming arcade, is easily one of the most popular and iconic tourist destinations in the Citadel, and some might argue in the entire galaxy. The crown jewel of this exciting playground, of course, is the Silver Coast Casino, with three floors of Quasar, roulette tables, varren racing booths, and a bar that serves mild-to-wild cocktails, depending on your mood.

Silver Coast is nothing if not lively, and I've included the following cocktails to help kick-start the excitement of your next big soirée—whether you're attending a charity gala for galactic war refugees or breaking into Elijah Khan's panic room, it's hard not to get a buzz from being surrounded by dolled-up attendees drinking fashionable cocktails!

WEEPING HEART

I simply love a flair for the dramatic: thieves leaving calling cards, villains monologuing, or devils bargaining. It elevates the stale and mundane, forcing you to reconsider traditional assumptions. And it doesn't get any more traditional than the martini, but *this*! The Weeping Heart! How could you resist something so elemental? No doubt named for the Drell Skin Venom (page 16) typically used to whip this one up. Or perhaps because it conjures the complex emotions of a heartbroken drell recalling every detail of a love long-lost. This drink is crisp, cool, searing, and spirit-forward, with a tingly effect from the aforementioned venom. To live is to feel, let the Weeping Heart remind you.

 SERVES:
1

 ICE:
None

 GLASS:
Martini

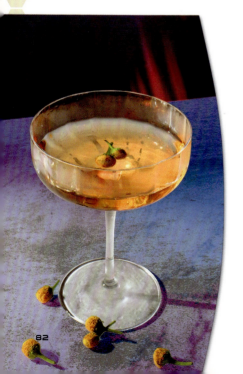

2½ ounces vodka

½ ounce dry vermouth

5 to 8 dashes Drell Skin Venom (page 16) or habanero or other spicy bitters

Garnish:
Szechuan button or dried chile pepper

1. Place the martini glass in the freezer for 10 to 15 minutes.

2. Add the vodka, vermouth, and Drell Skin Venom to a mixing glass and stir until well chilled.

3. Strain into the chilled martini glass using a barspoon and garnish with a Szechuan button or a dried chile pepper.

THE MINDFISH

Don't let their eminent politeness fool you. Hanar know how to party. They just don't do it with alcohol, seeing as dehydration doesn't exactly mix well with being mostly made of water. Their pick of poison is something called a mindfish, which has hallucinogenic skin oil that gets hanar buzzed up for the night. I should note that it would send a humanoid off on quite the weekend trip. Silver Coast Casino offers a more humanoid-friendly ode in cocktail form, The Mindfish, which can be made with alcohol, yerba matte, or a nootropic alcohol alternative like caffeine or L-theanine that supposedly boosts memory and focus in humans. This drink is typically garnished with nutmeg (not nearly enough for proper hallucinations, of course). And if you really want to party like the hanar, ditch your "face names" and give your party guests "soul names." They tend to be more elaborate if you've already had a couple Mindfish to drink.

 SERVES: 1 **ICE:** Standard, 1-inch cubes **GLASS:** Fishbowl or other rounded glass

2 ounces rum, yerba matte, or nonalcoholic nootropic alternative

2 ounces pineapple juice

2 ounces passion-orange-guava juice

½ ounce coconut cream

½ ounce lime juice

3 to 4 dashes pineapple and/or orange bitters (optional)

Garnish:

Lime slice

Freshly grated nutmeg

1. Add the drink ingredients to a cocktail shaker filled with ice. Shake vigorously for 10 to 15 seconds until well chilled.

2. Strain into a fishbowl glass. Add ice, as desired.

3. Garnish with a lime slice and freshly grated nutmeg.

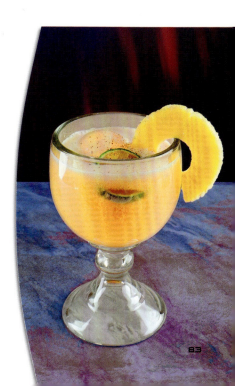

VOLUS BINA

An asari, quarian, and volus walk into a bar. The bartender asks, "What can I get you?" The quarian and volus motion to the asari, "Talk to her, we're just here for the atmosphere." A traditional Volus Bina is made with ammonia, but seeing as how that might not be the *wisest* thing for a non-Volus to consume, this recipe is more an homage to the original served up at Silver Coast Casino. It gets its flavor from foods with a high ammonia content—like chocolate, citrus, and almonds—that also happen to blend beautifully together. The aperol has a sort of strong and sour finish, smooth but potent, and the cocktail comes together with a chocolaty-orange flavor that is to die for (but not literally, so put down the ammonia).

 SERVES: 1 **ICE:** Standard, 1-inch cubes **GLASS:** Rocks or cocktail

1½ ounces rye whiskey

½ ounce peated whiskey (optional)

2 ounces aperol

1 ounce amaretto

½ ounce anise liqueur (like anisette)

½ ounce lemon juice

5 or 6 drops chocolate bitters

Garnish:

1 slice to ½ fig or 1 whole star anise

1. Add the drink ingredients to a cocktail shaker filled with ice.

2. Shake for 10 to 15 seconds until well chilled.

3. Strain into a cocktail glass; add ice to fill.

4. Garnish with a fig slice, a skewered fig sliced in half, and/or 1 whole star anise.

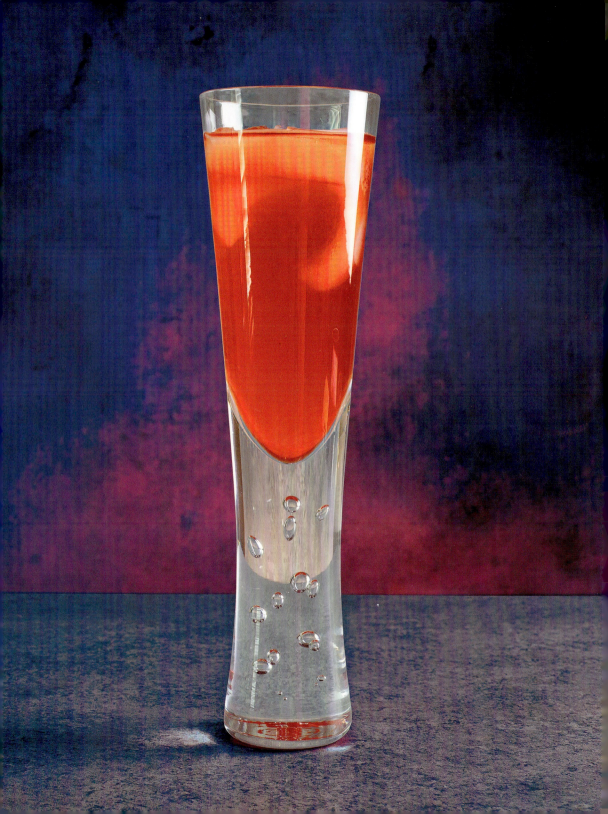

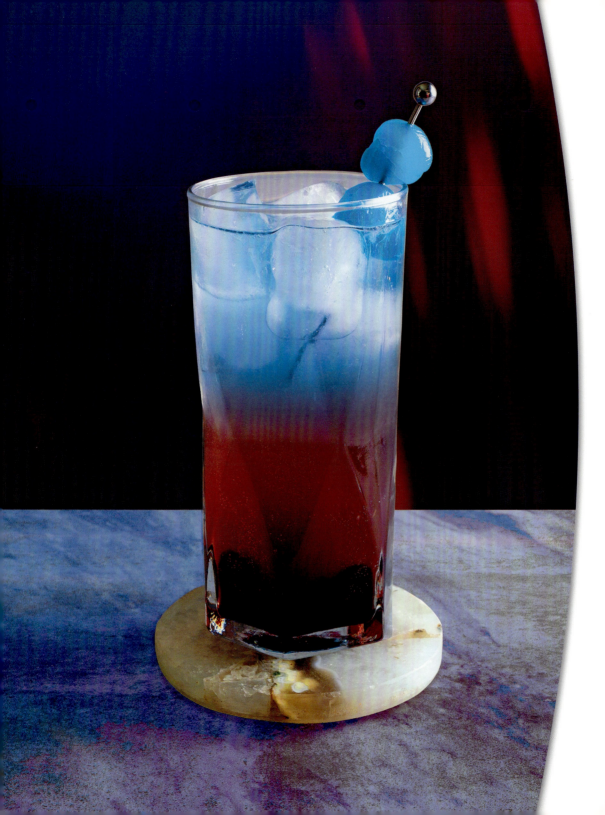

THESSIAN TEMPLE

The Thessian Temple is a classic drink that has withstood the tests of time and space. Instantly recognizable with its vivid blue-and-purple-gradient hue, sweet and tangy lemon-lime flavor, and effervescent bubbles, it's given to asari children (sans alcohol, of course) as a special treat—kids deserve to feel fancy, too. However, I have it on good authority that the Silver Coast Casino serves up a variation with a touch of maraschino liqueur and Blue Thessia for the grown-ups to enjoy. It's perfect to sip on for those nights where you'd prefer to walk a straight line on your way back to the skycars.

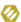 **SERVES:** 1 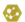 **ICE:** Collins spear or standard, 1-inch cubes **GLASS:** Collins or highball

2 or 3 Luxardo or blue maraschino cherries and their juices

½ ounce lemon juice

¼ ounce lime juice

2 ounces maraschino liqueur

2 to 3 ounces lemon lime soda

1 ounce Blue Thessia (page 10)

Garnish:
Luxardo or blue maraschino cherries

1. Add the cherries along with some of the juice from the jar or can to the bottom of a collins glass.

2. Fill the collins glass halfway full with standard ice cubes or a collins spear.

3. Add the lemon juice, lime juice, and maraschino liqueur. Add the lemon lime soda to the glass, leaving enough room for the Blue Thessia.

4. Add the Blue Thessia on top.

5. Give the drink one gentle stir to blend the layers before serving.

ASARI GELATIN SHOTS

If you're lucky enough to attend one of the parties hosted by Silver Coast Casino owner Elijah Khan, you can be sure that Asari Gelatin Shots will be on the menu. And why not? These are perfect party fare—they go down easy and kick like a Disciple shotgun. Asari Gelatin Shots really bring me back to my Maiden days . . . The taste is like a strong gin and tonic with lime. They're also very pretty to look at, with the purplish-pink color and sprinkles reminiscent of asari facial markings. Plus, the quinine in the tonic water will make them glow in the dark, so turn the lights low and get ready to embrace eternity!

◄ **SERVES:** 15 to 20 shots **ICE:** None **GLASS:** 15 to 20 plastic 1-ounce cups or shot glasses ►

2 cups tonic water

½ cup granulated sugar

Two ¼-ounce packets unflavored gelatin

¾ cup limeade

½ cup Blue Thessia [page 10]

½ cup navy-strength gin

2 tablespoons fresh lime juice

¼ teaspoon white luster dust (optional)

Garnish:

Blue, purple, and/or white sanding sugar

Star sprinkles

Metallic nonpareils

1. In a medium saucepan [do not heat yet], stir together the tonic water and sugar to taste until the sugar dissolves. Sprinkle in the gelatin and let rest for 5 minutes until the surface is slightly wrinkled.

2. Turn on the heat to medium-low. Heat for 2 to 3 minutes, stirring until the gelatin is completely dissolved. Do not boil!

3. Once the gelatin has completely dissolved, remove the gelatin mixture from the heat. Whisk in the limeade, Blue Thessia, gin, and lime juice. Add luster dust and more sugar if desired.

4. The mixture should be lukewarm. Pour into plastic 1-ounce cups or shot glasses and chill until set. This will take several hours, up to overnight. Keep chilled until ready to serve.

5. Sprinkle on the sanding sugar, sprinkles, and/or nonpareils just before serving.

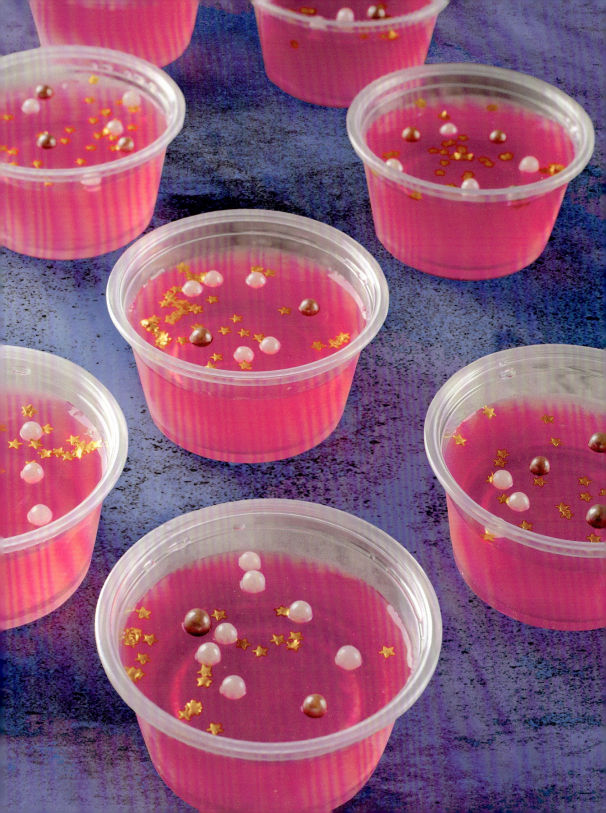

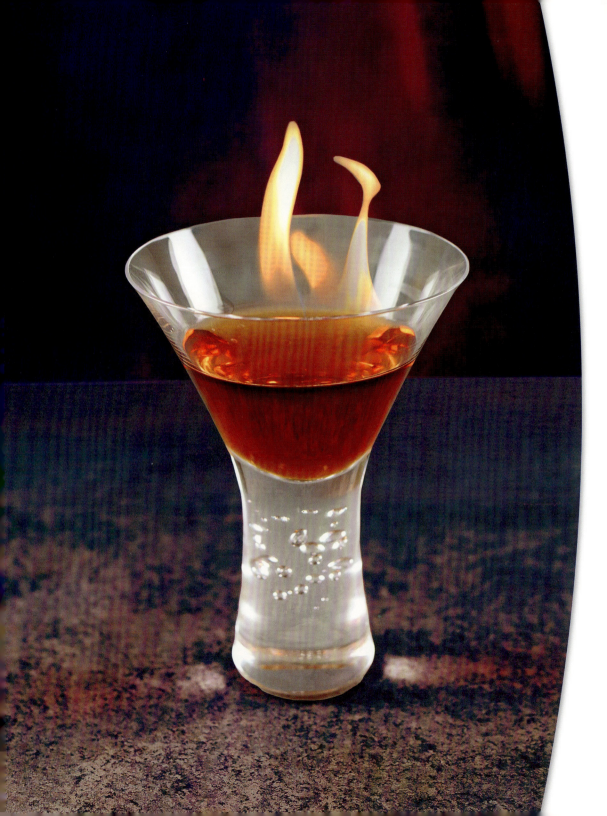

KROGAN BURUKH

Before my commando days, I started running with a krogan merc group who were looking for a biotic. I didn't have a lot of experience with krogan back then, and I admit they were an intimidating lot. Our first night together, the boys took me out drinking and I, wanting to seem just as tough as they were, did my best to keep up. Until they started ordering Krogan Burukh. It's a drink you set on fire, with a warm and spicy orange flavor that. *You. Set. On. Fire*. It'll pull your quads into your abdomen to see it done right. I'm not your mother, but I also don't want to hear your house burned down, so for the love of the goddess, treat this one with respect, yeah?

 SERVES: 1 **ICE:** Standard, 1-inch cubes **GLASS:** Tempered glass mug or other heat-resistant serving cup

1 ounce cinnamon liqueur or cinnamon whiskey

¾ ounce amaretto

½ ounce orange liqueur

4 to 6 dashes aromatic bitters

1 ounce high-proof whiskey (at least 90 proof)

Pinch cinnamon sugar

2 to 3 ounces seltzer water

Garnish:
Now, that just sounds like a fire hazard, doesn't it?

Special Equipment:
Long-necked lighter

1. Add the cinnamon liqueur, amaretto, orange liqueur, and bitters to a heat-resistant serving glass.

2. Place a spoon on the surface of the drink and slowly pour the whiskey onto the spoon, letting it overflow. The liquor should float on top of the liqueurs. Sprinkle some cinnamon sugar on top.

3. Turn the lights down low and use a long-necked lighter to set the whiskey on fire. Sprinkle a pinch of cinnamon over the flame to create extra sparkle.

4. Add the seltzer water and ice to fill, extinguishing the flames before taking a sip. Make sure the fire is completely out and the glass has cooled before consuming.

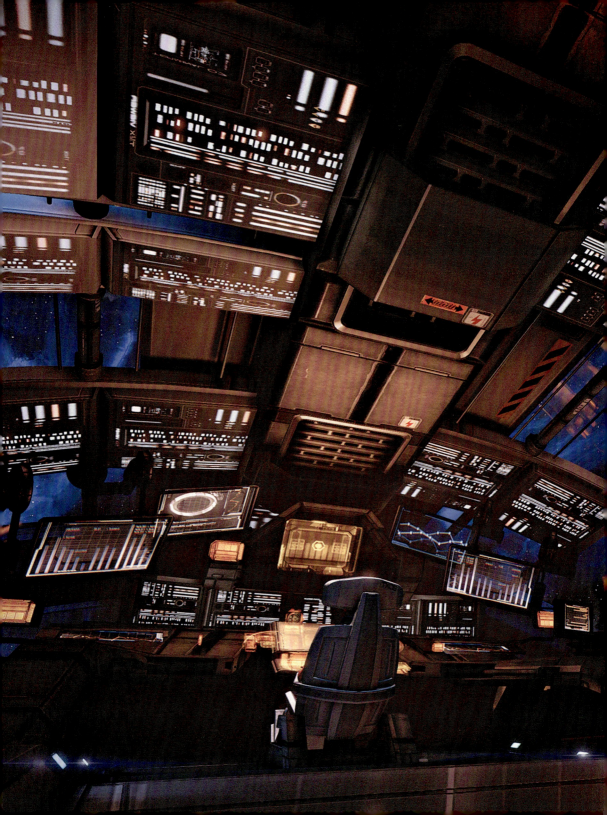

NORMANDY CREW CONCOCTIONS

As a former asari commando, I've certainly enjoyed my fair share of loud explosions, but I pride myself on having mastered the finer, more subtle arts of combat: espionage, assassination, and superior intel. On that last note, even someone who's been living under a mineral deposit has heard of the great human Spectre, Commander Shepard, and the crew of the Normandy—zigzagging across the galaxy, chasing rumors of a looming existential threat. But who are they really and what makes them tick? I like to go deeper than an Emily Wong fluff piece, so I pulled a few strings to find out.

You can learn a lot about someone from what they drink. Let's just say I was not disappointed when my sources for all things aboard the Normandy were able to procure the following recipes for me to pore over. Did I also swipe a personnel file or ten? Yes, but this gives it context and color. And though the drinks are very telling, I'm not—so fix yourself a glass of these Normandy Crew Concoctions and draw your own conclusions.

SUBJECT ZERO

Yes, I'm a criminal. I've been a pirate and an insurgent, and my hands are far from clean. But Cerberus is on another level entirely. I've had run-ins with biotically enhanced "subjects" they've manipulated, and all of them have been pushed to the limit. Take Jack, for instance. Arguably one of the most powerful human biotics alive, existing on booze and caffeine, she's not too fussy about how best to imbibe that combo for maximum effectiveness. The Subject Zero gets it done. I use green apple vodka and green apple energy drink to make it tasty. A toast to burning Cerberus to the ground.

◄ **SERVES:** 1 **ICE:** Standard, 1-inch cubes 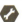 **GLASS:** Highball or whatever you can find ►

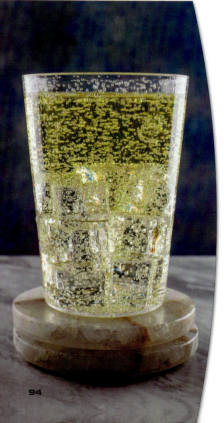

1 ounce green apple vodka

1 ounce rye whiskey

1 ounce bourbon

3 to 4 ounces green apple energy drink, chilled

Garnish:

None. Did you skip the "not-too-fussy" part? Are you trying to piss off Jack?

1. Add the vodka, whiskey, and bourbon to a tall glass filled with ice.

2. Top with the energy drink.

CALIBRATION COOLER

Turians may be imperialistic, inflexible, stringent, and bullheaded, but I appreciate that they rarely suffer nonsense. That's why this recipe comes with a tip I picked up from a rather notable turian, Garrus Vakarian. If someone keeps pestering you to talk or asks you to take on some tedious chore, you can always put them off with the following magic phrase: "Can it wait a minute? I'm in the middle of some Calibration Coolers." Maintain eye contact and repeat as often as necessary to get that nuisance off your back. Bonus: The drunker you get, the less you'll care.

 SERVES:
1

 ICE:
Crushed (for blender)

 GLASS:
Hurricane or poco grande

1 frozen banana
2 ounces pineapple juice
1 ounce coconut rum
1 ounce cream of coconut
1 cup crushed ice
1½ ounces blue curaçao
½ ounce orgeat syrup
1 ounce white rum
½ ounce lime juice

1. In a blender, add the frozen banana, coconut rum, pineapple juice, and cream of coconut. Purée until smooth.

2. Pour into a hurricane glass.

3. Clean out the blender, then add the crushed ice, blue curaçao, orgeat syrup, white rum, and lime juice to a blender. Purée until smooth.

4. Slowly pour the blue mixture into the white coconut–banana mixture until fully calibrated.

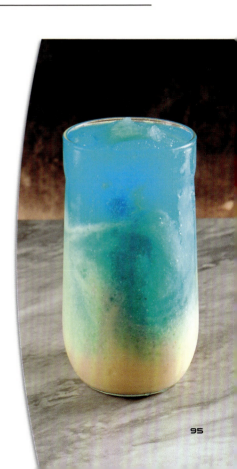

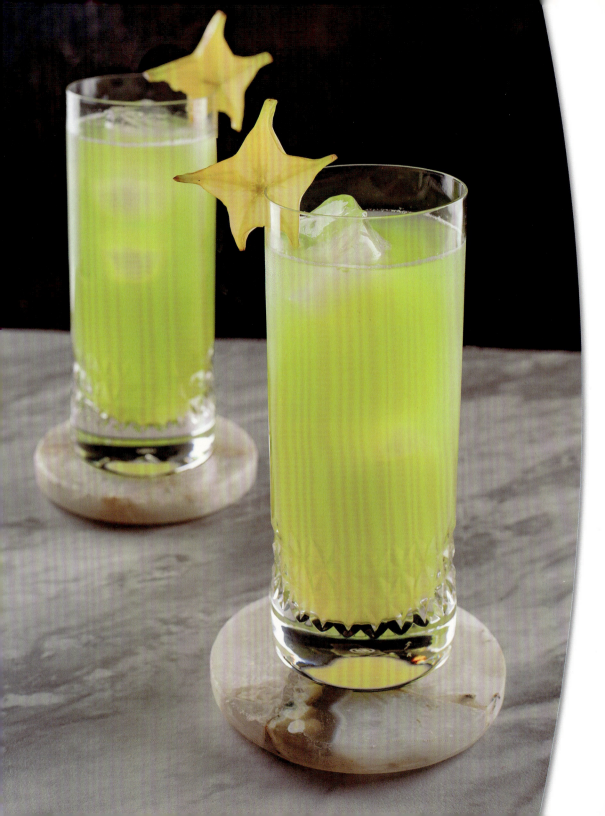

QUANTUM ENTANGLEMENT

There's something so romantic about the concept of quantum entanglement—that despite billions of light-years of distance, two subatomic particles can still somehow be ... *intimately* linked to each other. If you're looking to start something with Samantha Traynor (that's not a fight), I hear a husky, sexy voice waxing poetic about esoteric physics will do it ten out of ten times. Even if that voice belongs to an Enhanced Defense Intelligence (EDI) operating a gynoid infiltration unit. Not here to judge, if you need a list of extranet sites involving romantic relationships between organics and synthetics, I can recommend a few that'll really spin your hard drive. Serve up a couple of Quantum Entanglements while you're at it. I love this recipe for the sensual play of the vanilla flavor in the vodka with the cognac and passionfruit. Perfect to sip as you ruminate on the unknowable with that special someone.

 SERVES:
1

 ICE: Collins spear or standard, 1-inch cubes

 GLASS: Collins or highball

¾ ounce Blue Thessia (page 10)

2½ ounces passionfruit juice

1 ounce vanilla vodka

1 ounce cognac

2 ounces dry white wine

Garnish:

Starfruit or passionfruit, sliced ¼ inch thick and cut from the center

1. Add the Blue Thessia to a collins glass and fill with standard ice cubes or a collins spear.

2. Add the passionfruit juice, vanilla vodka, cognac, and wine to a cocktail shaker filled with ice.

3. Shake for 10 to 15 seconds until well chilled.

4. Strain the passionfruit mixture into the serving glass.

5. Give the drink a quick stir to blend the layers before serving.

JOKER'S CHALLENGE

I'm as competitive as they come, babe, but drinking contests feel antithetical to me. I prefer my drinks celebratory (and let my sidearm handle any disputes). Not so for Jeff "Joker" Moreau and Steve Cortez. These two pilots escalated a "guns vs. brains" hypothetical into a drinking contest followed by a trip to the gun range. I do, however, appreciate the poetry of them going shot-for-shot and then ... shot-for-shot. For the drinks portion of that contest, Joker's Challenge is an homage that substitutes antiseptic mouthwash (yes, really) with crème de menthe, keeping the mint "spirit" of the original "recipe," and I don't think I need to explain how well *that* pairs with an espresso and chocolate-infused rum. This one is a party-pleaser and there's no contesting that.

 SERVES:
1

 ICE:
None

 GLASS:
3-ounce double shot glass

1½ ounces Horse Choker (page 12) (or substitute ½ ounce black spiced rum and ¾ ounce crème de cacao)

1 ounce crème de menthe

Garnish:

Garnishing just slows down the contest!

1. Add the crème de menthe to a shot glass.

2. Place a small spoon in the glass and slowly pour the Horse Choker over the spoon so it sits on top of the crème de menthe.

3. If using black rum, layer the crème de cacao on top of the crème de menthe using the same method as above, then layer on the black rum on top of the coffee liqueur.

4. Drink the shot in one swig.

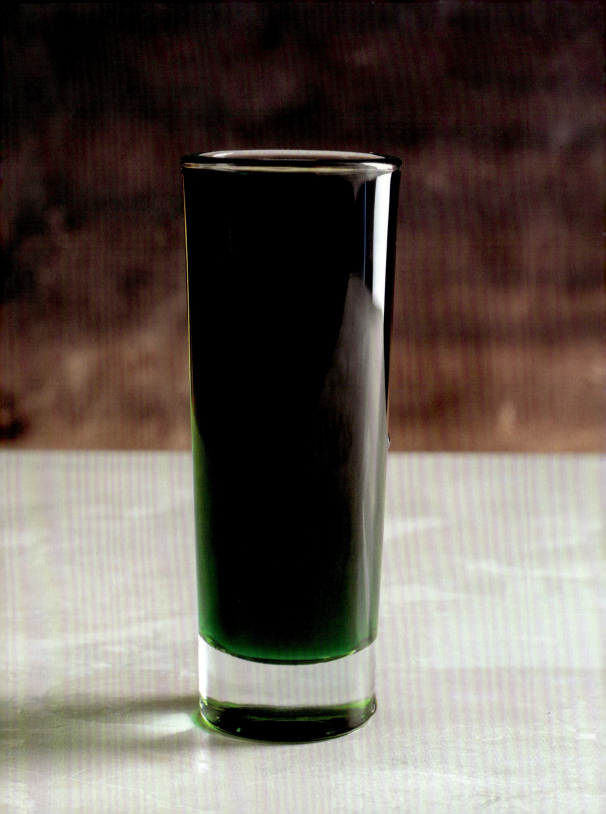

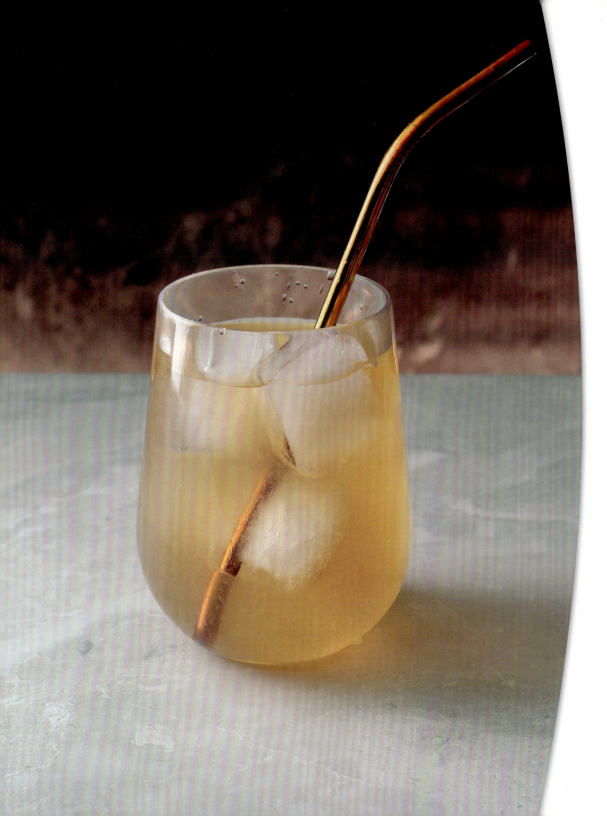

EMERGENCY INDUCTION PORT

There are two things quarians do better than anyone else: curse (say it with me: *bosh'tet!*) and get drunk. There's something indescribably charming about watching them start to slur words like "emergency induction port" until they become an unrecognizable mash of consonants and vowels. If you've never experienced it for yourself (hell, even if you have), then I recommend finding the nearest extranet terminal—I guarantee someone somewhere has uploaded such an interaction.

Anyway, my sources suggest this particular recipe is a favorite of a truly singular quarian, Tali'Zorah nar Rayya, especially when toasting to fallen friends. It is a simple, clean, and digestible drink that's best enjoyed through your emergency induction port (or *straw*, for us non-quarians).

 SERVES: 1 **ICE:** Standard, 1-inch cubes **GLASS:** Rocks

2½ ounces brandy

1½ ounces purified water

1 ounce lemon juice

½ ounce Simple Syrup (page 13)

2 to 3 drops orange bitters

Special Equipment:

1 emergency induction port (a straw)

1. Fill a rocks glass two-thirds full with ice.

2. Fill a cocktail shaker with ice. Add the brandy, water, lemon juice, simple syrup, and bitters to the shaker.

3. Shake for 10 to 15 seconds until well chilled.

4. Strain into the serving glass.

5. Drink through an emergency induction port.

THE N7 SHOOTER

N7 special forces, including those on the Normandy crew, are no joke. They're some of the most elite units in the galaxy and could easily go toe-to-toe with any asari commando unit I've seen in action. The N7 Shooter is a drink to be had in their honor: a delicious, layered shot, both sweet and caffeinated. It evokes the distinct white-black-red color scheme you'll find on their insignia. Seeing as November 7th is known on Earth as N7 Day, it's the perfect excuse to whip up a batch of these with your fellow cocktail commanders to toast to current and future graduates.

 SERVES: 1 **ICE:** None **GLASS:** 2-ounce shot glass

½ ounce grenadine

¾ ounce coffee liqueur

½ ounce horchata cream liqueur or white chocolate crème liqueur

Garnish:

None. Same as the room for error when an N7 graduate takes a shot.

1. Add the grenadine to a 2-ounce shot glass.

2. Hold a small spoon in the glass just above the surface of the grenadine. Slowly pour the coffee liqueur over the spoon so it settles on top of the grenadine.

3. Next, hold a small spoon in the glass just above the surface of the coffee liqueur. Slowly pour the horchata cream liqueur over the spoon so it settles on top of the coffee liqueur.

4. Drink the shot in one swig.

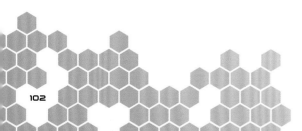

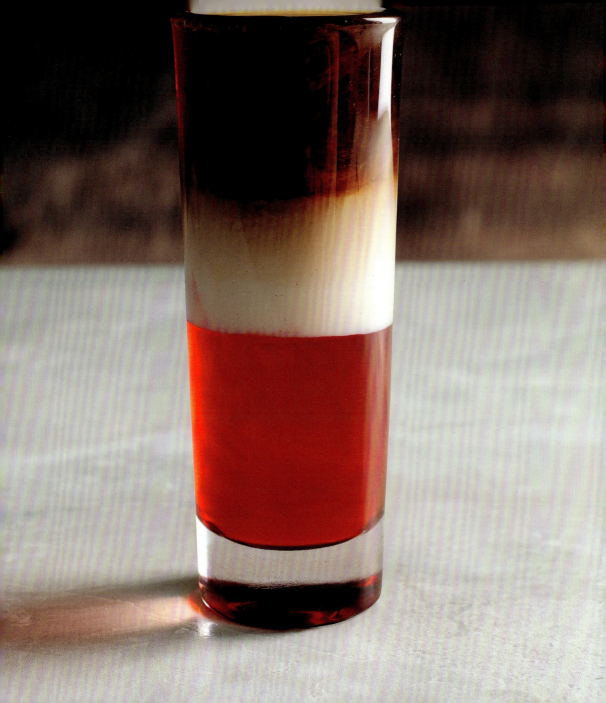

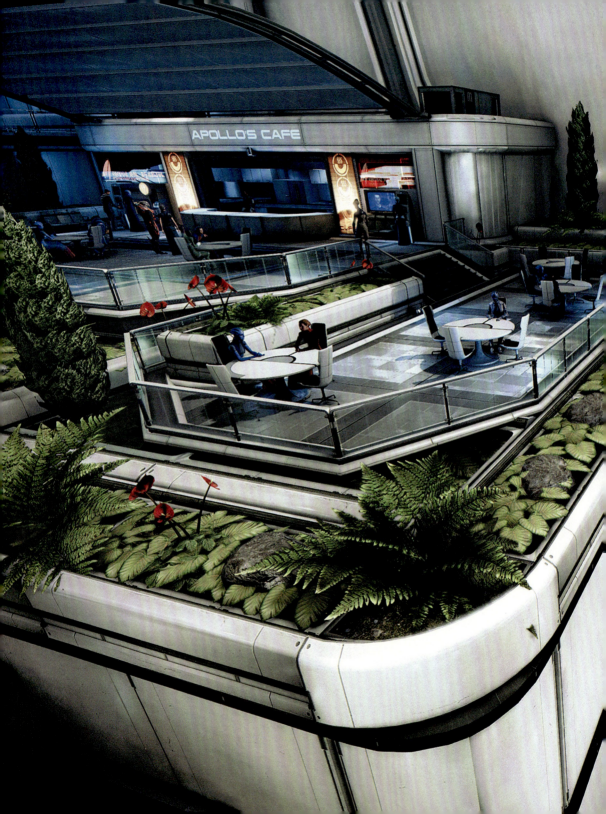

MILKY WAY
BAR SNACKS

I find that after a close brawl or blue-skin-of-my-teeth escape from a job gone (almost) wrong, I need something to snack on as much as I need a good drink. And let's be honest, no one likes a hangry drunk; they're that much closer to sticking a knife in your gut for giving them the wrong look. And what kind of host throws a shindig with fancy drinks and nothing to eat? Even batarian mothers raise their kids with better manners than that.

Plus, these recipes are fun. They're meant to be easily shared and prepared, so you can skip the forks and (especially) knives—which makes it that much harder for some drunk, cranky krogan to shank you. Bon appétit!

EDI'S CURRY SNACKS

You take the behavioral blocks off a Quantum Blue Box-type AI and give it a body, the next thing you know it's making snacks. Good thing, too, any decent watering hole needs snacks to munch on. This recipe (courtesy of the Normandy's EDI) has a little bite to it and goes especially well with ale-based cocktails. And while audio logs show shipmates Wrex, Samantha, and Kaidan are less on board with using curry powder, I'm with the fembot. Note that if you end up serving dextro nuts as well, you'll want to be sure to put them in a separate, distinct bowl so your human guests don't get cramps. Matriarch Aethyta likes to use red-colored ones, which gives humans that "STOP IT" feeling.

 SERVES: 8 to 10 **PREP TIME:** 15 minutes **COOK TIME:** 10 minutes **INACTIVE TIME:** None

2 tablespoons unsalted butter, melted

¼ cup pure maple syrup or honey

2 tablespoons soy sauce or tamari

2 tablespoons curry powder

1 teaspoon cumin powder

1 teaspoon sweet paprika

1 teaspoon smoked paprika

1 teaspoon garlic powder

1 teaspoon onion powder

½ teaspoon coriander powder

½ teaspoon sea salt

¼ teaspoon black pepper

Pinch cayenne

3 cups mixed nuts (raw and unsalted)

⅔ cup raw pepitas (pumpkin seeds)

½ cup dried goji berries and/ or cranberries (optional)

1. Preheat the oven to 350°F and line a rimmed baking sheet with parchment paper.

2. In a medium bowl, whisk together the butter, maple syrup, soy sauce, and spices. Add the nuts and seeds and toss with a spatula until evenly coated. Spread the mixture evenly on the baking sheet.

3. Bake for 8 to 10 minutes, stirring them about halfway through. The nuts are done when they are aromatic and slightly golden but not blackened or burnt.

4. Let the nuts cool to room temperature, then transfer to a mixing bowl. Stir in the goji berries and/or cranberries, if using. Taste and add more seasoning and/ or spices, if desired.

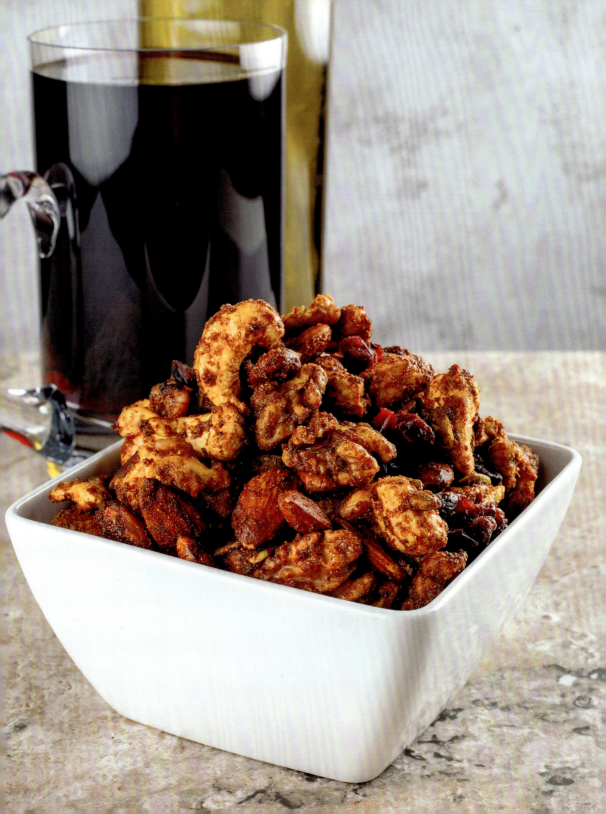

BURGAT:
THE OTHER BLUE MEAT

Regarding the burgat advertising campaign (we've all heard it: "Burgat! The *other* blue meat!"), I confess—I . . . don't know what "other" blue meat it's referring to. I hope it's not asari, but I wouldn't put anything past the batarians. Let's end our speculation there, because burgat is tasty enough to render "other" unimportant. Zakera Cafe added Tummy-Tingling Tuchanka Sauce to their burgat skewers, and now I simply can't have this dish without it. Either as a dip or slathered right on top of the grilled meat, this tummy-tingling topping is akin to human Thai peanut sauce.

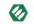 **SERVES:**
4 to 6

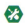 **PREP TIME:**
45 minutes

 COOK TIME:
30 minutes

 INACTIVE TIME:
9 hours to overnight

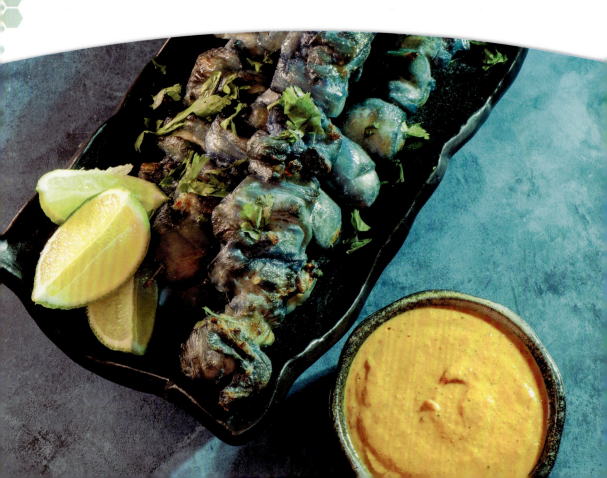

For the Burgat:

1 cup boiling hot water

2 teaspoons salt

1 tablespoon garlic powder

2 tablespoons granulated sugar

¼ cup dried butterfly pea flowers

1 pound boneless, skinless chicken thighs or breasts, cut into 1-inch pieces

For the Tummy-Tingling Tuchanka Sauce:

¼ cup creamy peanut butter or sunbutter

2 cloves garlic

2 tablespoons soy sauce

2 tablespoons fresh lime juice

2 tablespoons light brown sugar

1 tablespoon curry powder

1 tablespoon turmeric powder

1 tablespoon chile garlic sauce

One 2-inch piece fresh ginger, peeled

1 teaspoon Szechuan peppercorns

2 tablespoons warm water (or as needed)

To serve:

2 lime wedges

Fresh cilantro, chopped

Special Equipment:

Large, sealable storage container or marinating container

6 to 8 wooden skewers

1. First, prepare the marinade. Add the hot water, salt to taste, garlic powder, sugar, and butterfly pea flowers to a large container suitable for marinating a pound of chicken. Do not add the chicken yet. Let the marinade seep for at least 1 hour at room temperature. Once the marinade has cooled to room temperature, place it in the fridge for 2 to 3 hours, up to overnight.

2. Once the marinade is a deep dark blue, remove and discard the butterfly pea flowers. Add the chicken to the marinade. Let the chicken marinate for at least 6 hours, preferably overnight.

3. Remove the chicken from the marinade, which can be discarded. Pat the chicken pieces dry with paper towels. Thread the chicken onto the skewers, folding the longer pieces if necessary. If using wooden skewers, soak them in warm water for 20 to 30 minutes. You'll likely use 6 to 8 skewers. Once the chicken is on the skewers, wrap the exposed part of skewers with aluminum foil.

4. If using a grill, grease the grates with oil and preheat to medium-high heat. Cook the skewers, covered, over indirect heat for 6 to 9 minutes per side, or until the chicken has completely cooked through and the internal temperature reads 165°F. Remove the skewers from the oven and let the meat rest for 10 minutes before serving.

5. If using an oven, preheat the oven to 450°F. Line a baking sheet with parchment paper and arrange the skewers with as much space as possible between them. Cook the skewers for 7 to 10 minutes, then flip them to the other side and cook for another 7 to 10 minutes. Switch the oven mode to broil and let the skewers broil for 2 to 4 minutes. Once the meat has a nice brown color and an internal temperature of 165°F, remove the skewers from the oven and let the meat rest for 10 minutes before serving. Discard the foil, if using.

6. Add all the sauce ingredients to a blender or food processor and blend until smooth. Taste and adjust the ingredients as necessary. Pour the sauce into a small shallow bowl and set aside.

7. Serve the skewers with lime wedges and a side of the Tummy-Tingling Tuchanka Sauce. Sprinkle with chopped cilantro, if desired.

TASTEE BITES

If you're looking for something cheesy, snacky, and crunchy to pair with your Batarian Ale Shandy (page 30), start with Tastee Bites. You can buy economy boxes of them in bulk from the Fishdog Food Factory (I've watched krogans go through several in one sitting), but the homemade version is a little more flavorful because you get to use real cheese instead of synthetic. Experiment with flavorful hard cheese based on your preference, and keep in mind the homemade version is even more addictive and snacky than store-bought.

 SERVES: 15 to 20 **PREP TIME:** 30 minutes **COOK TIME:** 30 minutes **INACTIVE TIME:** 30 to 60 minutes

½ cup unsalted butter, cold, cut into tablespoons

¾ cup Gruyère or Emmentaler, grated

½ cups smoked cheddar or gouda, grated

1 cup sharp cheddar, grated

1 teaspoon kosher salt

1 teaspoon smoked paprika

½ teaspoon garlic powder

¼ teaspoon black pepper

⅛ teaspoon cayenne

1¼ cups all-purpose flour

Special Equipment:
Food processor
1½-inch round cookie cutter

1. In a food processor, pulse the butter, Gruyère, smoked cheddar, sharp cheddar, salt, paprika, garlic powder, pepper, and cayenne to taste until the mixture forms small rice-size pieces. Add in the flour and pulse until larger clumps form.

2. Transfer the dough to a lightly floured work surface and form a ball. Separate the dough into two equal pieces. In between two sheets of wax paper, roll out each piece into a disk about ¼ inch thick. Working with one dough disk at a time, peel off the top sheet of wax paper. Using a small (1½-inch) round cookie cutter, stamp out the cookies as close together as possible. Arrange the cookies about 1 inch apart on the prepared baking sheet. Repeat until all the dough has been used, rerolling the dough as needed.

3. Place the baking sheet in the refrigerator for 30 minutes, up to 1 hour.

4. Preheat the oven to 350°F.

5. Bake the cookies in the preheated oven for about 10 minutes. Rotate the baking sheets from top to bottom, then bake for another 10 to 15 minutes until the cookies are lightly golden. Let the cookies cool on the baking sheets for 5 minutes, then transfer them to a wire rack to cool completely.

HERBED DEXTRO CHEESE

If you've got quarian and turian friends on your guest list, Herbed Dextro Cheese is the perfect party dip. Note that quarians don't usually bother with herbs in their cheese, so triple-check before you trigger a toxin treatment program in someone's enviro-suit. This dish tastes great with a variety of dippers, making it a versatile party option. Bonus: The loud crunching also drowns out awkward conversations!

 SERVES: 6 to 8

 PREP TIME: 30 minutes

 COOK TIME: 10 minutes

 INACTIVE TIME: 90 minutes

3 tablespoons olive oil

2 baguettes, sliced ½ inch thick

Assortment of crackers

Raw veggies and fruits (your choice)

For the cheese:

¼ cup fresh basil leaves, finely chopped

¼ cup chives, chopped

¼ cup flat-leaf parsley, chopped

One 8-ounce package cream cheese

One 8-ounce log chèvre

1 teaspoon pure matcha powder, for color (optional)

1 teaspoon dried sage

½ teaspoon garlic powder

2 teaspoons dijon mustard

1 tablespoon lemon juice

2 teaspoons lemon zest

2 teaspoons cracked black pepper

½ teaspoon kosher salt

Fresh herb sprigs, for garnish

Special Equipment:

Food processor

1. Preheat the oven to 375°F. Arrange the bread slices on two heavy baking sheets. Drizzle the olive oil over the bread slices. Bake until the crostini are golden and crisp, about 10 minutes.

2. In a small bowl, stir to combine the fresh herbs. Set aside.

3. Place the cream cheese and chèvre in a food processor and blend until creamy.

4. Add in half of the herbs and pulse a couple times. Then add the seasonings, including the matcha powder, if using. Blend until combined. Taste and adjust the seasoning as needed. With a silicone spatula, scoop the mixture out onto a piece of plastic wrap. Wrap and refrigerate for 30 minutes.

5. After 30 minutes, spread the remaining herbs over a cutting board or other flat surface. Remove the cheese mixture from the fridge and form it into a ball. Roll the ball around in the chives to coat. Cover the ball with plastic wrap again and refrigerate it for 30 more minutes before serving.

6. Serve with the crostini and a cheese knife for spreading, along with an assortment of crackers, veggies, and other accompaniments of your choice.

HUEVOS RANCHEROS À LA VEGA

There's something special about battle-tested recipes that have been handed down through generations. You could choose to follow them to a T or make adjustments to put your personal stamp on things. Or a mix of both! Alliance marine James Vega got this breakfast pleaser from his grandmother who insisted that he not adjust the ranchero sauce. Not. One. Tiny. Bit. But she didn't say anything about the beans. So, to save time, James started using canned refried black beans instead of making them from scratch. I also picture him cracking the eggs with his biceps, but maybe that's just me. Huevos Rancheros à la Vega—who wants some eggs?

SERVES: 4	PREP TIME: 15 minutes	COOK TIME: 30 minutes	INACTIVE TIME: None

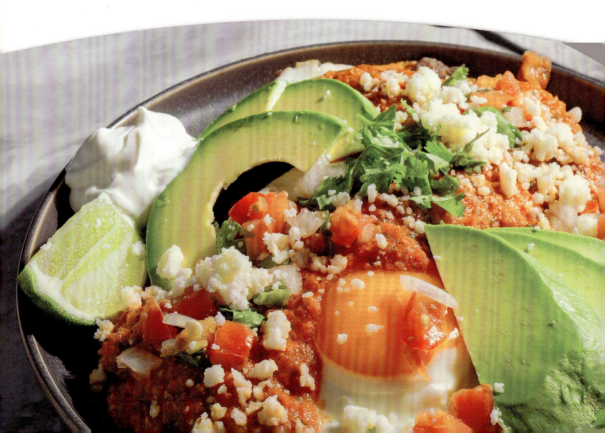

For the ranchero sauce:

1 tablespoon olive oil

½ large white onion, diced

3 Roma tomatoes, diced

1 jalapeño, seeded and diced

1 chipotle pepper in adobo sauce, chopped

2 cloves garlic, minced

¼ teaspoon kosher salt

½ teaspoon Mexican oregano

½ cup chicken broth

¼ cup fresh cilantro, chopped

2 tablespoons fresh lime juice

For the huevos rancheros:

One 16-ounce can refried black beans

4 round tostada shells

1 tablespoon unsalted butter

4 large eggs

½ cup crumbled cotija cheese, for topping (optional)

Fresh cilantro, chopped, for topping (optional)

1 avocado, sliced, for serving (optional)

Pico de gallo, for topping (optional)

Sour cream, for topping (optional)

1. First, make the ranchero sauce. Heat the olive oil in a large skillet over medium-high heat. Add the onions, tomatoes, jalapeño, chipotle, garlic, salt to taste, and oregano. Cook for 10 minutes, stirring occasionally, until the onions and peppers have softened. Add the chicken broth, stirring to combine, and cook for 30 more seconds. Remove the sauce from the heat and stir in cilantro and lime juice.

2. Pour the sauce into a blender and pulse until it reaches the consistency you prefer. Pulsing a couple times will produce a chunkier sauce, whereas continuous puréeing will produce a smoother sauce. Taste and adjust the seasoning as needed. Set aside.

3. Warm the beans in a small saucepan on medium-low heat. While they warm up, cook the eggs.

4. Heat the butter in a medium skillet over medium heat. Once the butter starts to bubble, crack the eggs into the pan, then cover the pan with a lid. Allow the eggs to cook gently over low heat for about 2 to 3 minutes, or until the egg whites have fully set and the yolks are done to your preference. Season with salt and pepper to taste.

5. Spread the warmed black beans on the tostada shells and add a fried egg on top of each one. Ladle on the ranchero sauce to taste. Add the sliced avocado, sour cream, and/or pico de gallo, if using. Sprinkle the cotija and fresh cilantro over each portion before serving.

SPICY RAMEN NOODLES

It's easy to work up an appetite when you're bouncing around the Silversun Strip. Whether you've spent your day gaming at the arcade, combat simulator, or roulette wheel at the Silver Coast Casino, some Spicy Ramen Noodles are the perfect dish to refuel before a night on the town. A derivation from traditional ramen, these are more akin to Dan Dan Noodles or Tantanmen, which I've found to be a more approachable, bar-friendly dish. I procured this recipe from the Noodle House on the strip, so you know it's good.

 SERVES: 4 **PREP TIME:** 30 minutes **COOK TIME:** 30 minutes **INACTIVE TIME:** None

For the spicy sauce:

2 tablespoons sesame paste (sub tahini and/or peanut butter)

1 tablespoon doubanjiang or sambal oelek

2 tablespoons soy sauce

3 tablespoons black vinegar or balsamic vinegar

1 tablespoon honey

½ teaspoon five-spice powder

½ teaspoon ground Szechuan peppercorns

¼ cup chile oil

2 cloves garlic, minced

1 tablespoon fresh ginger, grated

1. In a small mixing bowl, mix all the spicy sauce ingredients together with a whisk. Taste and adjust the heat levels with more doubanjiang and chile oil, if desired. Set aside.

2. In a large skillet over medium-high heat, heat the oil. Add the pork, breaking up the meat with a wooden spoon. Cook, stirring occasionally, until the meat is browned and slightly crispy, about 3 to 4 minutes.

3. Stir in the remaining pork ingredients with about a ½ cup of hot water. Continue to cook on medium heat until the excess liquid has either evaporated or absorbed, about 5 to 7 minutes.

4. Cook the noodles according to package instructions and set aside. Drain all but one-quarter of the pasta water and set aside.

5. Add the sauce to a large mixing bowl, then add the drained noodles to the sauce, tossing to coat. Add the hot pasta water as needed to thin the sauce if it's too thick to coat.

6. Divide the noodles among serving bowls and top each with the ground pork. Top with generous amounts of green onions, cilantro, cucumber, chiles, and peanuts. Squeeze some fresh lime juice over the top, if desired. Mix before eating.

For the pork:

1 teaspoon neutral oil

½ pound ground pork (or vegan substitute)

2 teaspoons sweet bean or hoisin sauce

1 tablespoon rice vinegar

1 tablespoon brown sugar

2 teaspoons sake

1 teaspoon soy sauce

1 teaspoon toasted sesame oil

1 teaspoon fresh ginger, minced

½ teaspoon five-spice powder

To assemble:

1 pound ramen noodles

Green onions, sliced on a bias, for topping (optional)

Fresh cilantro, chopped, for topping (optional)

1 cucumber, peeled and julienned, for topping (optional)

1 bird's-eye chile, sliced, for topping (optional)

Chopped roasted peanuts, for topping (optional)

Lime wedges, for serving (optional)

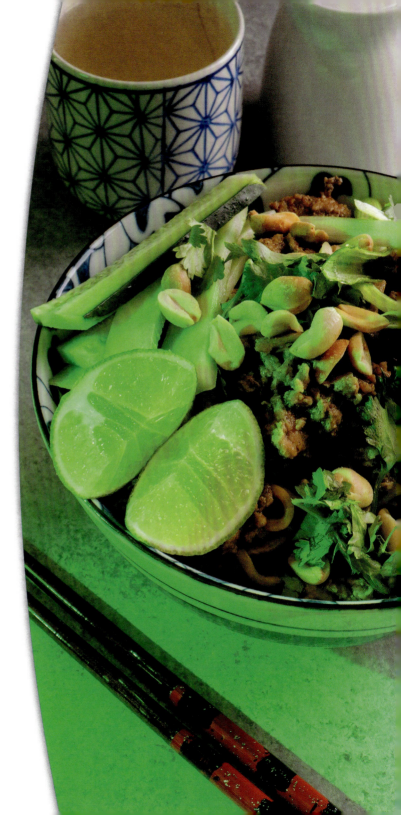

KAIDAN'S STEAK SANDWICH

We asari tend to take biotics for granted. So, I confess I was caught off guard when a tipsy young Alliance marine opened up to me about "brain camp," a rather crude early training facility for biotics. On the anniversary of his graduation (which sounded more like a prison break), he liked to celebrate his freedom with "beef, bacon, and beer—the food of my people." The next time I saw him, I let him know that I'd perfected this recipe and named it in his honor, a light and shareable open-faced sandwich with a delicious beer-bacon jam. And a side of Canadian whiskey, of course.

 SERVES: 1 to 2 **PREP TIME:** 45 minutes 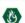 **COOK TIME:** 1 hour **INACTIVE TIME:** 6 hours to overnight

For the marinade:

½ cup olive oil

½ cup balsamic or red wine vinegar

3 tablespoons brown sugar

8 cloves garlic, minced

1½ teaspoons kosher salt

1 teaspoon red pepper flakes

1 teaspoon black pepper

1. First, make the marinade. Combine the oil, vinegar, brown sugar, garlic, salt, red pepper flakes, and black pepper in a secure container or sealable freezer bag. Set aside 1 to 2 tablespoons of the marinade.

2. Pierce the steak in several places on both sides with a fork. Place the steak in the container with the marinade, making sure it is completely covered. Let the steak marinate in the fridge for 6 to 8 hours or overnight.

3. Meanwhile, make the jam. Fry the bacon in a large skillet over medium heat until all the fat has been rendered out and the bacon is crispy. Drain the excess fat and add the butter, red onion, shallot, garlic, and black pepper. Cook over low heat for about 20 minutes, stirring frequently to prevent burning, until the onions have caramelized. Stir in the maple syrup, balsamic vinegar, beer, and thyme. Simmer for another 20 to 25 minutes, until most of the liquid has reduced and the mixture reaches a jam-like consistency. Store in a glass container in the fridge until ready to assemble the sandwiches. The jam can be reheated in the microwave for 20 to 30 seconds.

For the beer-bacon jam:

6 to 7 slices thick-cut bacon, cut into lardons

2 tablespoons unsalted butter

2 large red onions, finely chopped

1 shallot, thinly sliced

4 to 6 cloves garlic, minced

½ teaspoon black pepper

¼ cup pure maple syrup

2 tablespoons balsamic or red wine vinegar

4 to 5 ounces Canadian lager

½ teaspoon dried thyme leaves

For the sandwich:

1 pound flank, strip, ribeye, or skirt steak

1 tablespoon olive oil

1 to 2 tablespoons unsalted butter, plus more as needed

1 baguette, halved lengthwise and quartered

1 bunch baby arugula and/or watercress

Salt to taste

Pepper to taste

Special Equipment:

Sealable freezer bag or container

Cast-iron skillet

4. Remove the steak from the marinade and pat dry with a paper towel, discarding the used marinade. Heat 1 tablespoon of olive oil in a cast-iron skillet over medium-high heat. Once the oil is hot, add 1 tablespoon of butter. Once the butter has melted and started to bubble, add the steak. It should start to sizzle immediately upon hitting the pan. Pan-fry the steak in the butter for 3 to 4 minutes on both sides, until both sides have a good sear and the internal temperature reaches 145°F for medium-rare. Add more butter as needed. You can also grill the steak over medium-high heat for 6 to 8 minutes, flipping it halfway through cooking, until the internal temperature is 145°F.

5. Once cooked, remove the steak from the heat and let it rest on a carving board for 10 to 15 minutes. Once rested, slice the steak against the grain into thin slices.

6. Lightly toast the baguette slices. Spread the bacon jam onto each baguette slice. Drape the steak slices on top of the jam layer. Top each with some arugula and drizzle with the unused marinade that you set aside. Serve warm.

RYUUSEI ROLL SPÉCIALE

I'm not one for lines, but when I tell you the wait at Ryuusei Sushi is worth it, I mean it. Serving "authentic French sushi," their Ryuusei Roll Spéciale is a must-order. Assuming you get in, of course. Lucky for you, I've included a recipe for you here, but don't let this one intimidate you: It's upscale fusion cuisine designed for home cooks of all kinds. If anything ever happened to that place, I don't know what I'd do ... but it would be violent.

 SERVES: 2 **PREP TIME:** 30 minutes **COOK TIME:** None **INACTIVE TIME:** 30 minutes

For the special sauce:

¼ cup apricot jelly

½ Fresno or bird's-eye chile, seeded and minced

1 clove garlic

1 to 2 teaspoons sesame oil

2 teaspoons Dijon mustard

2 teaspoons soy sauce

2 teaspoons rice vinegar

2 teaspoons light brown sugar

One 1-inch piece fresh ginger

1 to 2 tablespoons sweet chile sauce

1. In a blender, add all the sauce ingredients except the sweet chile sauce and purée until smooth. Pour into a small bowl and mix in the sweet chile sauce to taste. Set aside.

2. Let the rice cool to room temperature, then mix in the mascarpone and Parmesan until well combined. The rice should be very sticky.

3. Lay out two or three slices of dry-cured ham or prosciutto on a bamboo sushi mat or a piece of parchment paper. Spoon half of the rice mixture onto the ham. Use damp hands to spread the rice evenly across the ham, pressing down slightly to adhere it. Arrange half of the arugula across the bottom-third part of the ham/rice. Using the sushi mat or parchment paper for leverage, carefully roll the preparation into a tight log, sealing it with wet fingertips. Cover the roll tightly with plastic wrap and set aside in the fridge for 20 minutes. Repeat the process with the remaining dry-cured ham, rice mixture, and arugula.

4. After 20 minutes, remove the rolls from the refrigerator and discard the plastic wrap. Using a very sharp knife, cut the rolls crosswise into 1-inch "maki" rounds.

5. Transfer the maki rolls to a serving plate and use a spoon to drizzle on the special sauce. Top with toasted sesame seeds and garnish with microgreens and/or edible flowers. Serve immediately!

For the "maki" roll:

1 cup sushi or arborio rice, cooked

⅓ cup crème fraîche or mascarpone cheese

½ cup Parmesan cheese, grated

7 ounces dry-cured ham (like Bayonne or serrano) or prosciutto

½ cup arugula or watercress

¼ cup sesame seeds

Microgreens and/or edible flowers, for garnish (optional)

Special Equipment:

Bamboo sushi mat or parchment paper

Plastic wrap

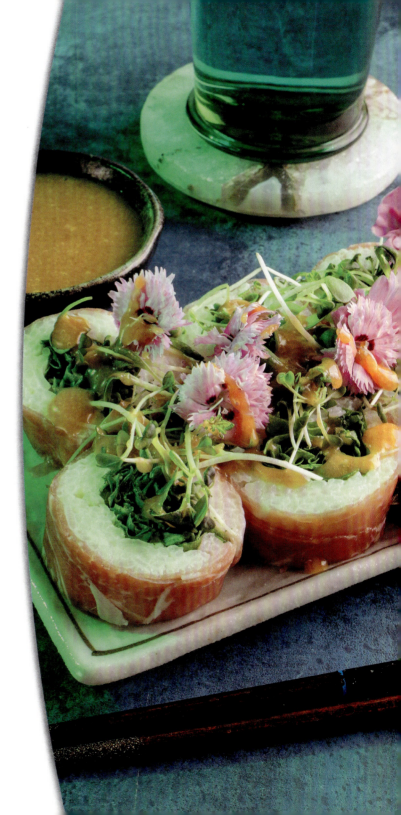

CHOCOLATE LAVA BOMB CAKE

The lava cake is a misunderstood human dessert. But if you know, then you *definitely* know. It is not undercooked. It's a unique combination of traditional chocolate cake and soufflé, which makes it cakey on the outside with an irresistible molten chocolaty inside. This particular Chocolate Lava Bomb Cake recipe includes a booze infusion of either Tuchanka Dry or bourbon. Alliance pilot Steve Cortez got it from his aunt, who claims the hooch gives it an almost biotic ability to Pull you in and hold you in Stasis after that first bite.

◀ **MAKES:** 5 **PREP TIME:** 20 minutes **COOK TIME:** 15 minutes **INACTIVE TIME:** None ▶

6 ounces semisweet chocolate

4 ounces unsalted butter, softened, plus more for greasing

1 tablespoon Tuchanka Dry or bourbon (optional)

3 medium eggs

¼ cup granulated sugar

¼ cup all-purpose flour

1 teaspoon vanilla paste or extract

1 teaspoon espresso powder or instant coffee

Star sprinkles or confectioners' sugar, for dusting (optional)

Vanilla ice cream, for serving (optional)

Chocolate sauce, for serving (optional)

Special Equipment:

Five 4-ounce ramekins or dome molds

1. Preheat the oven to 400°F. Generously grease five 4-ounce ramekins or dome molds with butter.

2. In a microwave-safe bowl, stir together the chocolate and butter. Microwave the mixture in 20-second increments, stirring in between each session, until the mixture is completely smooth. Once smooth, stir in the bourbon and set aside.

3. In a separate large mixing bowl, beat the eggs and sugar until pale and fluffy. Lightly beat in the melted chocolate, flour, vanilla, and espresso powder until just combined. Do not overmix.

4. Divide the batter into the ramekins and place them on a baking sheet. Bake for 10 to 12 minutes or until the edges begin to pull away from the ramekins but the center is still jiggly.

5. Remove the cakes from the oven. Let them cool in the ramekin for 10 minutes, then release the cakes from the ramekins (a knife may be required around the edges) onto the serving plate. Dust with confectioners' sugar or sprinkle with star sprinkles. Serve with a scoop of ice cream and drizzle with chocolate sauce, if desired.

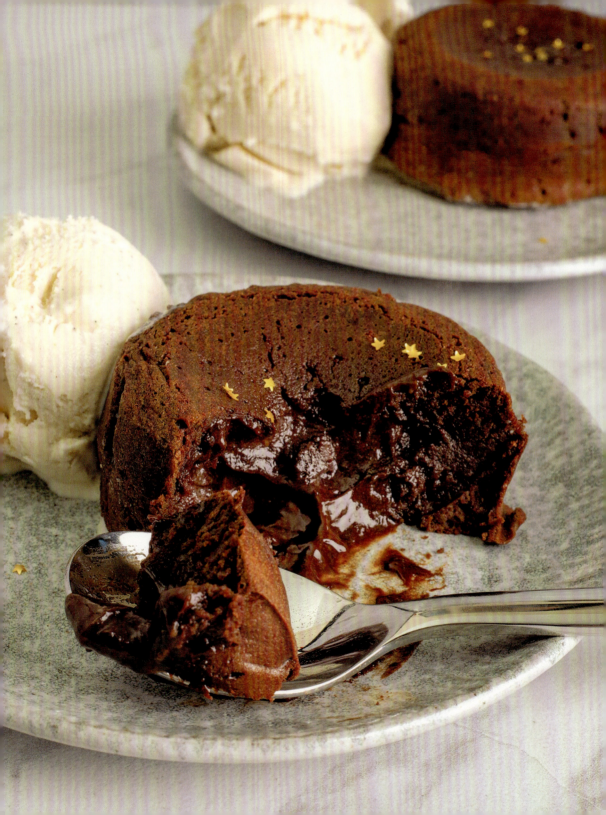

ANDROMEDA

Milky Way Year: 2819, addendum to the capable work of Ambree T'Sia.

Hello, my friend! When I was accepted to live among the aliens of the Jarevaon Imasaf (or Milky Way, as they call it) aboard their massive space station Nexus, I said isharay to my angara family and set out for adventure . . . but I did not know I would end up restoring and amending a book about it!

Encouraged to familiarize myself with their culture, I came across the most interesting volume in the Andromeda Initiative's archives—this one that you now hold. A truly lucky find, for how better to know someone than by ingesting their food and consuming their beverages? My thanks, dear Ambree T'Sia! But the particular (and if I'm honest, peculiar) way denizens of that galaxy have of speaking can be challenging to follow, so I took this book to cantankerous-chemist-turned-brusque-bartender Dutch Smith and his affable co-manager Anan T'Mari at the Vortex for guidance and a good deal of translation. Dutch, with some prodding from Anan, thus began his tutelage. Each new recipe informed and expanded my endless curiosity for their home galaxy. It also gave me an idea . . .

After Pathfinder Ryder successfully stabilized the Remnant vault on Havarl, I was eager to assist with our fledgling alliance. So, I proposed that I update this fabulous tome with recipes concocted and collected from across Andromeda, from colonists and indigenous alike, that we may further link our two galaxies in a gesture of friendship and cooperation. After all, as my wise tutor Anan tells it, what is a better way to break the ice between species than with a good drink?

—Andromeda citizen and Nexus exchange volunteeer
Roa of the angara

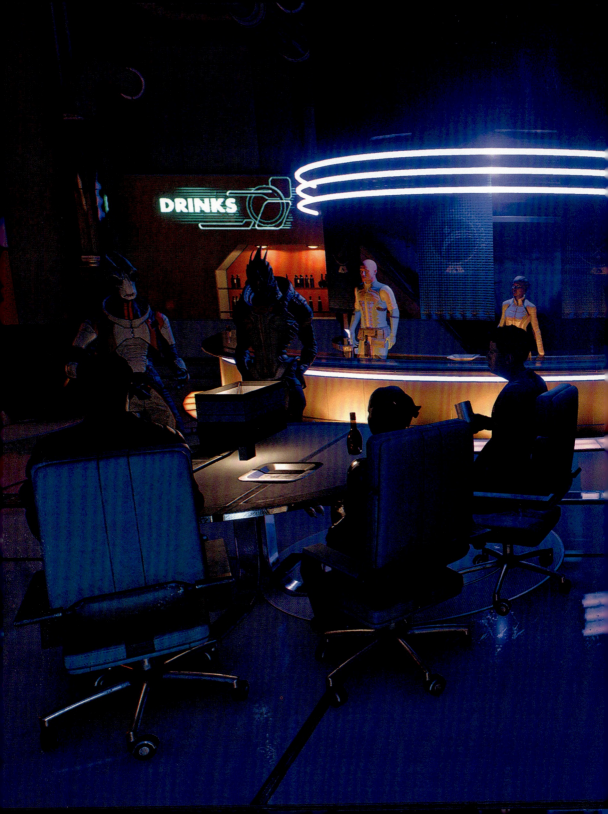

THE VORTEX

I believe I endeared myself to Dutch (as much as one can) when I asked him to explain the concept of a vortex. Struggling to understand his words, I confessed to being more of a visual learner. Dutch grabbed a beer from a bar patron, silenced the mouthy one's protestations, and began to vigorously stir said brew with a straw. "That," he said, pointing to the mass of swirling liquid at the center of the glass.

"Ah! How aptly named, our little improvised bar," I replied, "Seeing as how it swirls together the inhabitants of the Nexus, an irresistible force drawing them in, as they twist and interact in complex and exciting ways!" He stared at me for quite some time. I began to fear I had spoken out of turn. But it was Anan who washed the glasses and mopped the floor that night while Dutch and I tended to the last stirrings of our evening's customers. The following recipes are some of my favorites, and I take great pride in them. Seeing as how our Vortex originally began as a chemistry lab, these drinks have more of an experimental feel!

TALL MOOSE

Oh, Canada! This Earth nation is rich in culture, wildlife, and video game developers (I play Alliance Corsair on my omni-tool!). Its vast lands birthed frozen tundra to rival Voeld—filled with fierce, antlered creatures known as a moose. To honor these fearsome beasts, Dutch created the Tall Moose, a cocktail that utilizes Canadian whiskey and something called "maple syrup," the sweet blood of vanquished trees most often found atop panned cakes. Have one Moose, or several Mooses! Meese? Bah, sometimes I feel this confusing language was invented by purposely spiteful *vehshaanan as teroshe* . . .

 SERVES: 1 **ICE:** Collins spear or standard, 1-inch cubes 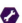 **GLASS:** Collins or highball

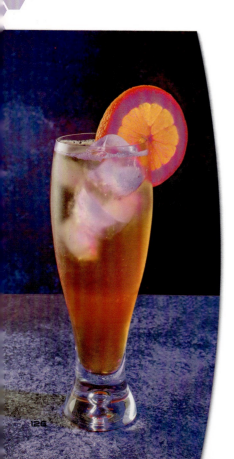

2 ounces Canadian whiskey (or other rye whiskey)

¾ ounce maple liqueur or maple whiskey

1 ounce pure maple syrup

¼ ounce lemon juice

3 to 4 dashes Peychaud's bitters

2 to 3 ounces sparkling wine or saison-style beer

Garnish:

Orange slice or wheel

1. Fill a collins or highball glass two-thirds full with standard ice cubes or a collins spear.

2. Add the whiskey, liqueur, maple syrup, lemon juice, and bitters to a cocktail shaker filled with ice.

3. Shake well, then strain into the tall serving glass.

4. Top off with sparkling wine or saison.

5. Garnish with an orange slice.

DIRTY SQUIRREL

Have you heard of squirrels? They very much enjoy a diet of nuts! To that effect, Dutch has concocted what he calls a Dirty Squirrel, which employs a mixture of hazelnut, walnut, and almond liqueurs. The "dirty," I have inferred, comes from the many infectious diseases these adorable rodents carry within their small furry bodies. I shall confirm with Anan on that last point . . .

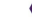 **SERVES:** 1 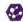 **ICE:** Standard, 1-inch cubes (for the shaker only) **GLASS:** Martini, coupe, or cocktail

2 ounces bourbon

1 ounce hazelnut liqueur

1 ounce walnut liqueur

½ ounce amaretto

2 to 4 dashes walnut bitters (optional)

1 ounce cream

Garnish:

¼ teaspoon freshly grated nutmeg

Special Equipment:

Grater

1. Add the bourbon, hazelnut liqueur, walnut liqueur, almond liqueur, and bitters to a cocktail shaker filled with ice.

2. Shake vigorously for 15 to 20 seconds until well chilled and slightly frothy.

3. Strain into a chilled martini or coupe glass.

4. Hold a spoon over the surface of the drink. Pour the cream slowly over the spoon so that the cream floats on top of the bourbon mixture.

5. Sprinkle freshly grated nutmeg over the top of the drink and serve.

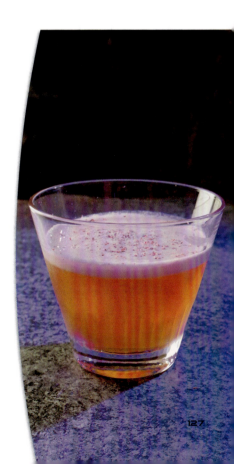

LUCKY LEPRECHAUN

On Earth, a tiny race of wizened humanoids who live under rainbows, get drunk, start fights, make shoes (or breakfast cereal; there are variances in the telling), and, if caught, must surrender all their credits to the fortunate hunter. Truly! Angry little things that hail from a place called Ire Land. Sadly, I do not believe any came over to Andromeda on the arks. May a Lucky Leprechaun cocktail bring you equally good fortune—drinking enough of them has been known to bring on quite the jig. Who knew Pathfinder Ryder was so flexible?

 SERVES: 1 **ICE:** Standard, 1-inch cubes **GLASS:** Rocks, cocktail, or lowball

2½ ounces Irish whiskey

½ ounce absinthe

2½ ounces sour apple schnapps

½ ounce cinnamon liqueur

Garnish:

Gold sprinkles or sanding sugar

Ground cinnamon

Corn syrup or honey

Edible gold leaf

1. If using gold sprinkles, add them and the cinnamon to a shallow small bowl. Stir to combine and spread the sugar mixture around so the bottom of the bowl is covered.

2. In a separate small bowl, add just enough corn syrup or honey to cover the bottom of the bowl.

3. Dip the rim of the serving glass in the syrup. Place the glass upside down in the sanding sugar and rotate so the sugar sticks to the rim. Set the glass aside.

4. Add the whiskey, absinthe, schnapps, and cinnamon liqueur to a mixing glass filled with ice.

5. Stir until well chilled.

6. Strain into a serving glass two-thirds full of ice and garnish with gold leaf.

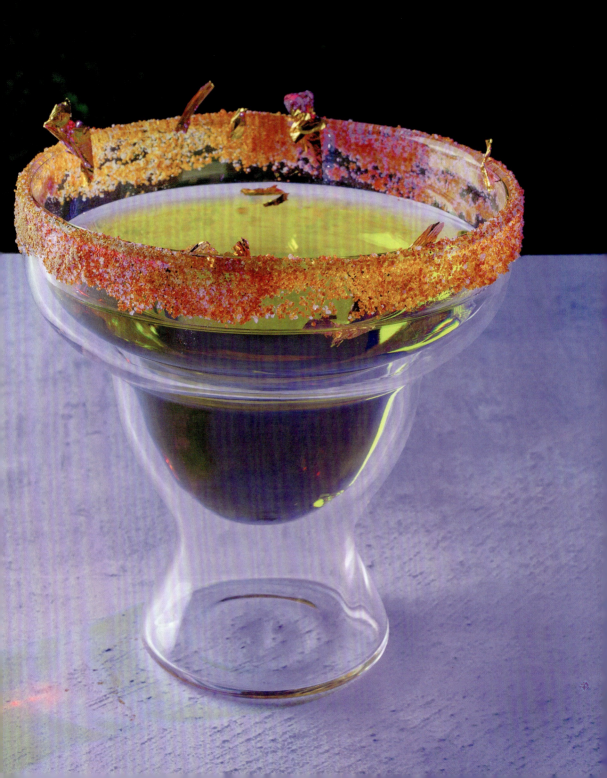

PINK MARBLE

I have heard the humans refer to their ancestral planet of Earth as a "Blue Marble." This term was coined from their early days of space exploration, whereupon viewing their home world, they collectively felt a sense of loneliness and fragility. When I gaze upward on Havarl, the mighty gas giant that hangs in the sky has a pinkish hue to it. Might I suggest a refreshing ode to finding allies in a place beyond the Blue Marble—a Pink Marble. And a toast to the life, however improbable, you are fortunate to share together with friends.

 SERVES: 1 **ICE:** 1 sphere (plus standard ice for the cocktail shaker) **GLASS:** Fishbowl, margarita, or other wide-mouthed glass

2 ounces pink gin (sub London Dry)

2 ounces ruby-red grapefruit juice

½ ounce Tupo Concentrate (page 15) or grenadine

¼ ounce lime juice

Garnish:

1 strawberry, sliced with the leaves removed

1. Add the sphere ice and strawberry slices to a wide-mouthed serving glass.

2. Add the drink ingredients to a cocktail shaker filled with ice.

3. Shake vigorously for 10 to 15 seconds until well chilled.

4. Strain into the serving glass with the sphere ice and strawberry slices.

ROTTEN SCOUNDREL

I quite enjoy open mic night at the Vortex. What fun it is to bear your soul so nakedly to complete strangers! Dutch, decidedly, does not, and Anan has often warned him that the deep creases from scowling so fiercely at turian poetry are becoming quite permanent. The Rotten Scoundrel is his house special these nights (to pan the "rotten, bad apples" ruining his evening) and employs the use of apple cider vinegar to achieve a crisp, tart cocktail.

 SERVES:
1

 ICE:
Standard, 1-inch cubes

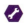 **GLASS:**
Rocks or lowball

1½ ounces spiced rum

1 ounce calvados

½ ounce apple cider vinegar

¾ ounce Asari Honey Syrup (page 17)

3 to 5 dashes aromatic bitters

2 to 3 ounces hard apple cider

Garnish:

Dehydrated lemon wheel

Fresh sage leaves

1. Add the rum, calvados, vinegar, syrup, and bitters to a cocktail shaker filled with ice.

2. Shake for 10 to 15 seconds until well chilled.

3. Strain into the serving glass, add hard apple cider, and fill with ice.

4. Garnish with a dehydrated lemon wheel and/or fresh sage leaves.

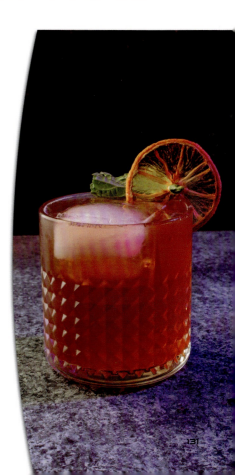

KRALLA'S SONG

I once beheld a glorious bar brawl instigated by some ruffians who picked a fight with the human Pathfinder Ryder and the krogan mercenary Drack at Kralla's Song. The Pathfinder's grit and persistence overcame—proprietor Umi Henon even stepped into the fray with a percussive clash of bottle on face!

Despite choosing to name her bar after the asari demon of misfortune—and there is much misfortune in Kadara Port—Umi has shown me that even when faced with insurmountable odds, small and courageous steps toward change are better than no step at all. Her drinks reflect an adventurous spirit and grit we angara can relate to and appreciate.

COMBAT JUICE

Nakmor Drack was one of the first krogan I ever met. He was a fearsome example of a proud warrior people. I only saw him taken down once . . . by Umi! Or to tell it more true, by Umi's Combat Juice. Much like the Milky Way's Frozen Pyjak (page 42) I discovered in Ambree T'Sia's writing, Umi's cocktail takes an "everything-all-at-once" approach to drink-making. In this light and to thus tell it most true: Rather than a single foe, it can be said Drack was only able to be brought low by a veritable army of alcohol!

 SERVES: 1 **ICE:** Standard, 1-inch cubes **GLASS:** Pint glass or pilsner

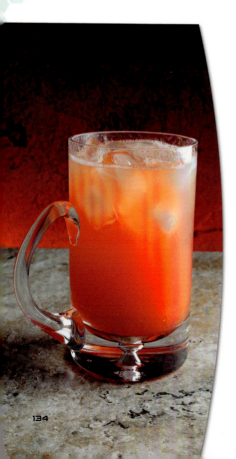

1 ounce Tupo Concentrate (page 15) or grenadine

½ ounce vodka

½ ounce spiced rum

½ ounce gin

½ ounce bourbon

½ ounce orange liqueur

½ ounce lemon and/or lime juice

2 to 3 ounces passion-orange-guava juice

2 to 4 ounces light beer or champagne

Garnish:

1 maraschino cherry

1. Fill a beer glass or a pint glass half-full with ice.

2. Add the Tupo Concentrate or grenadine.

3. Add the vodka, rum, gin, and bourbon.

4. Add the orange liqueur and juices.

5. Top with the beer or champagne.

6. Garnish with a maraschino cherry.

UMI'S EXPERIMENT

Umi and I were discussing the particulars of angaran wine, after Pathfinder Ryder deemed it safe for humans and asari. "I think I may have found the perfect pairing for this," she told me, and thus I was introduced to something the krogan call ryncol. While that beverage tastes like it would be better suited to fueling a starship, I must agree that the combination of the two is surprisingly quite pleasant, effervescent even ... for angara, asari, or krogan at least. When ingested by humans, it brings about a flurry of wild, uncontrolled gesticulation they claim is "dancing" but appears more akin to a violent seizure.

 SERVES:
1

 ICE:
Collins or standard, 1-inch cubes

 GLASS:
Collins or highball

1½ ounces 100-proof vodka

1 ounce melon liqueur

1 ounce lime cordial

1 or 2 drops Salarian Salination Solution (page 14)

2 to 3 ounces sparkling wine

Garnish:

Lime twist

1. Fill a tall glass two-thirds of the way with standard ice cubes or use a collins spear.

2. Add the vodka, liqueur, lime cordial, and saline to the glass.

3. Add the sparkling wine and give the drink one quick stir to mix. Garnish with a lime twist.

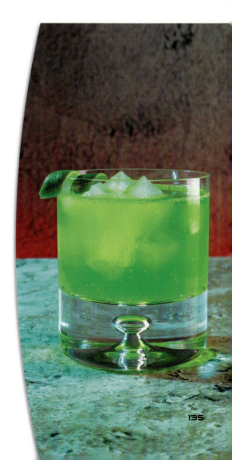

HOT SPICED TAVUM

In the spirit of cultural exchange, I would be most honored to introduce you to the Angaran Word of the Day: Tavum! This delightful drink is a pleasant angaran intoxicant stirred into hot water or fruit juice. For our purposes here, let us prepare a Hot Spiced Tavum, which I understand from human friends tastes like a combination of rum and bourbon. Add to that a syrup to create a most enjoyable cocktail. This drink warms one from the inside and non-angara have found it to be a more pleasurable way of staying warm than relying on Voeld's heat lamps. Taerve uni!

◄ **SERVES:**
1　　 **ICE:**
None　　 **GLASS:**
Glass mug　　►

1 or 2 cinnamon sticks

1 or 2 whole star anise

1 or 2 whole allspice

3 to 4 ounces boiling water

2 ounces dark rum

1 ounce bourbon

1 ounce maple syrup

½ ounce lemon juice

Special Equipment:
Pot or tea kettle

1. Add cinnamon sticks, star anise, and allspice to a glass mug.

2. Pour in the boiling water and let the spices steep for 3 to 5 minutes.

3. Add the rum, bourbon, maple syrup, and lemon juice.

4. Stir and remove allspice berries before serving.

5. Leave the cinnamon sticks and star anise in for garnish.

TAVUM & JUICE

In the spirit of cultural exchange, I would be most honored to introduce you to the Angaran Word of the Day: It is still Tavum! Instead of a Hot Spiced Tavum (page 136), let us this time prepare a Tavum & Juice, whose origins were said to arise from a (now forgotten) angara pirate, who would combine fruit from the kitchens with alcohol to boost morale when times were lean. Drack, Vetra, and Peebee insist it be served with tiny little umbrellas! Whoever would need such a thing? Unless... have I been misled about the existence of leprechauns (page 128)?

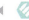 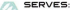 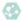 **SERVES:** 1 **ICE:** Crushed (plus standard, 1-inch cubes for shaker) **GLASS:** Hurricane, poco grande, or zombie

2 ounces dark rum

1 ounce bourbon

1 ounce falernum

3 to 4 ounces pineapple–orange–banana juice

½ ounce crème de cassis or Tupo Concentrate (page 15)

Garnish:

Maraschino cherries

Orange slices

1 cocktail umbrella

1. Fill a hurricane glass to the top with crushed ice.

2. Add the rum, bourbon, juice, falernum, and crème de cassis or Tupo Concentrate to a cocktail shaker filled with standard ice cubes.

3. Shake well. Strain into the hurricane glass.

4. Garnish with a cocktail umbrella, orange slices, and cherries.

AKANTHA FIZZ

Before the kett stole Kadara Port from the angara (we took no real joy to see it stolen in turn by Sloane Kelly and her Outcast warband), I am told the trading center there would outfit adventurers who wished to camp beneath the summit. Recounting this to Umi, my prickly friend and I set about concocting a cocktail in that spirit. She introduced a bottle of asari alcohol called Akantha, whose advertisements evoke much nostalgia for herself, as well as Dr. Lexi T'Perro. This is indeed a special item, known for its warm, smoky flavor and sweet aftertaste (in lieu of Akantha, mezcal offers similar notes and can be substituted). Umi finished the Akantha Fizz with a burning herb garnish—surprising for one who prides herself on a "no-frills" approach to tending bar! Though upon further reflection, she does enjoy lighting things on fire.

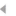 **SERVES:** 1 **ICE:** Standard, 1-inch cubes for shaker **GLASS:** Hurricane or zombie

2 ounces mezcal

1 ounce cherry brandy or cherry liqueur

1 ounce Asari Honey Syrup (page 17)

4 to 5 dashes aromatic bitters

2 to 3 ounces sparkling water

Garnish:

1 or 2 Luxardo or bourbon cherries

Fresh rosemary sprig

Smoked sea salt or smoky bitters

Special Equipment:

Lighter (optional)

1. Fill a hurricane glass with ice.

2. Add the mezcal, cherry liqueur, asari syrup, and bitters to a cocktail shaker filled with ice.

3. Shake for 10 to 15 seconds until well chilled.

4. Strain into the serving glass.

5. Top with sparkling water.

6. Spear the cherries with the sharp end of the rosemary sprig. Drop it in the drink.

7. Sprinkle the drink with smoked sea salt or smoky bitters.

8. If desired, light the end of the rosemary sprig with a lighter. Do not consume until the sprig has fully burned.

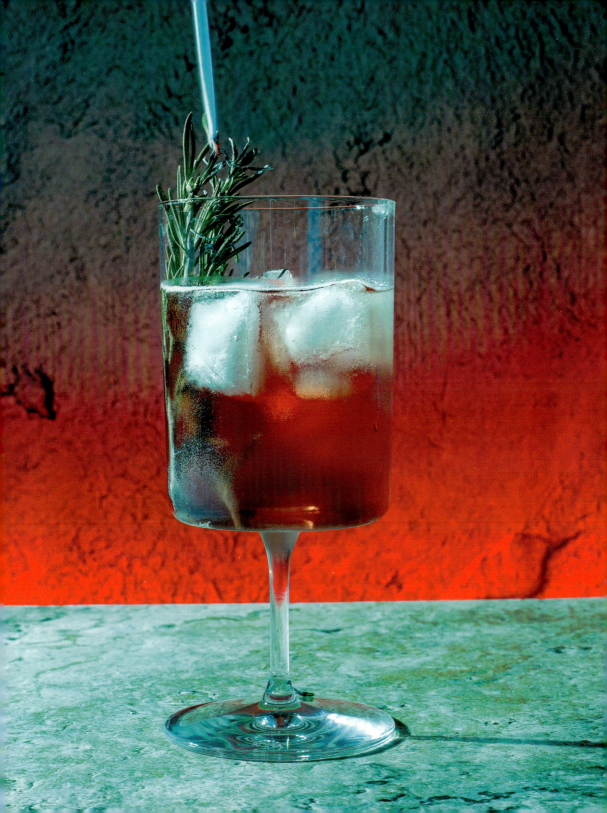

TARTARUS

Kian Dagher's Tartarus is a dangerous nightclub in the center of the Kadara Slums. Though I would not wish to travel there myself, it does provide a decent distraction from the brutal living conditions in the area. If you are feeling particularly reckless (or sufficiently desperate), I've heard there are bootleggers beyond the slums, but I felt nothing would be lost by omitting their contributions from my collections.

Kian's offerings are some of the more exotic recipes I have collected, most likely because they contain alcohol that is hard for a non-smuggler to procure on Kadara. Off-worlders will have an easier go, but I trust any Kadarans reading this are capable enough to find a way or clever enough to make the appropriate substitution where necessary.

MARLJEH

We angara have a phrase to explain outlandish behavior, usually uttered with a conspiratorial wink or an exasperated sigh—depending on who is doing the outlandish behaving relative to the observer, of course. We say: "Too much marljeh!" *Juggling loaded Ushior?* "Too much marljeh!" *Gone off to join the Roekaar?* "Too much marljeh!" *Living with the humans?* "Too much marljeh!" (Well, I suppose this one does have a ring of truth to it!) Have I convinced you to try Marljeh yet? Good! This version can be made with or without alcohol and includes some caffeine from the matcha to create a nice flavor buffer.

 SERVES:
1

 ICE:
Standard, 1-inch cubes

 GLASS:
Cocktail, rocks, or lowball

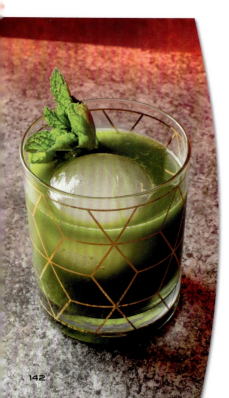

2 ounces spiced rum

2 to 4 ounces spiced apple cider

½ ounce lime cordial (sweetened lime juice)

¼ ounce Asari Honey Syrup (page 17)

1 tablespoon pure matcha powder

Garnish:

1 sprig mint

1. Fill a cocktail shaker with ice. Add the rum, as well as the apple cider, lime cordial, asari honey syrup, and matcha powder.

2. Shake until all the matcha powder has dissolved and the liquid is well chilled.

3. Strain into a cocktail glass two-thirds full of ice. Garnish with a mint sprig.

KADARA SUNRISE

The Kadara Sunrise! Tartarus's most popular cocktail, Kian Dagher insists it is also the Pathfinder's favorite drink. How interesting that such a vibrant cocktail, with its beautiful gradient of colors designed to emulate the planet's hazy sulfur sky, is the cocktail of choice in a place as desperate and miserable as the slums. Angara sometimes boast that the humans have much to learn from us. I feel differently . . . What strength, what power we would have, if we shared their resilience. Oh, to possess such human certainty that one day we shall see the sun rise free from violence, free from occupation, free from the kett. When that day comes, may Tartarus's patrons, humans and angara alike, toast that victory with a round of Kadara Sunrises.

 SERVES: 1 **ICE:** Collins spear or standard, 1-inch cubes **GLASS:** Highball or collins

¾ ounce Tupo Concentrate (page 15) or grenadine

½ ounce peach schnapps

2 ounces peach pineapple juice (sub peach juice or a mix of peach and pineapple)

2 ounces bourbon or whiskey

½ ounces cream of coconut

3 to 4 dashes aromatic bitters

Garnish:

1 or 2 peach slices

1 or 2 cocktail cherries

1. Add the Tupo Concentrate to a highball glass, then fill with ice cubes or a collins spear.

2. Add the peach schnapps, juice, bourbon, and cream of coconut to a cocktail shaker filled with ice. Strain into the highball glass.

3. Add the aromatic bitters, then give the drink a quick stir.

4. Garnish with cherries and peach slices.

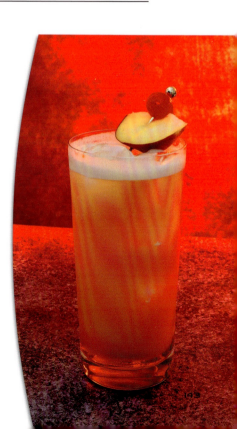

DROSSIX BLUE

For the purposes of transparent recordkeeping, I should confess my own bias in choosing to include this recipe. I cannot shake my fascination with Vetra Nyx. This cyclone of a turian is battle-tested, but also knows how to relax when the climate is less violent. In these quieter moments, she sometimes speaks of celebrating with the angara over a bottle of Drossix Blue once the kett have been properly dealt with. Provided our physiology can tolerate it, of course. Human stomachs have been known to burst from consumption, so I suggested a modified Drossix Blue using champagne (for the bubbles!) and blue curaçao (for the, well, blue!) as a more compatible and decidedly less murder-y beverage.

 SERVES:
1

 ICE:
None

 GLASS:
Champagne flute

1 ounce blue curaçao

½ ounce lime juice

1 ounce tequila

2 to 3 ounces ginger ale, chilled

2 to 3 ounces bière brut or champagne, chilled

Garnish:

1 orange slice

1. Chill a champagne flute in the freezer for 10 minutes.

2. Pour in the blue curaçao, followed by the lime juice and tequila.

3. Add the ginger ale and top off with the bière brut or champagne.

4. Garnish with an orange slice.

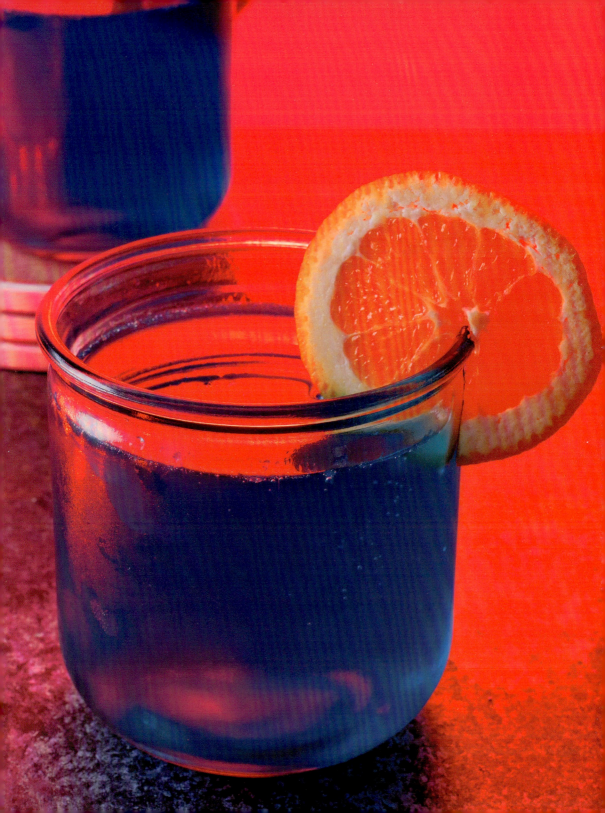

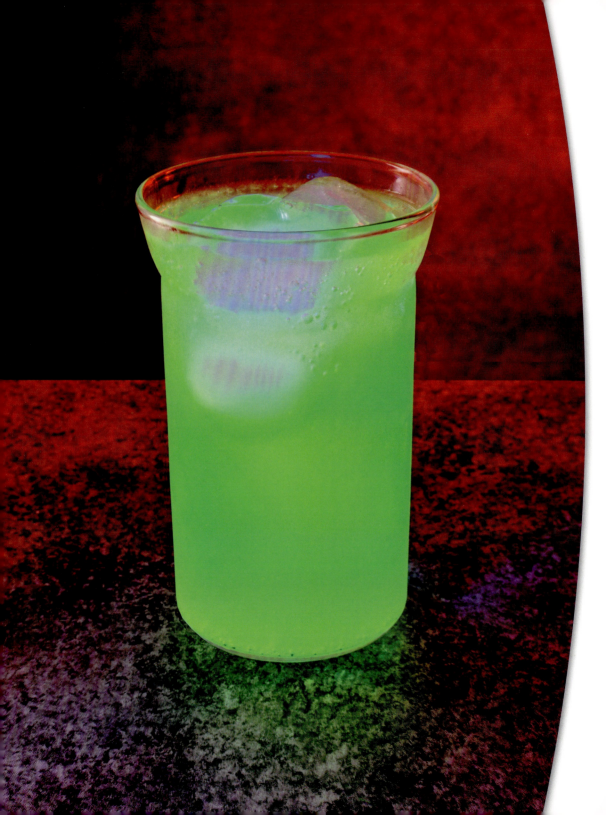

SLUMWATER

Humans have developed a sort of mental protection against subjects considered serious and frightening. Rather than succumbing to their suffering ... they *laugh* at it. "Gallows humor" is as abundant in the slums as the slum water. For instance, take Slumwater! A strong drink served to rowdy customers, its taste is strong, and its look is decidedly radioactive and formulated to glow under a blacklight. Hilarious, I think! Kian insists you could take a glass and collect water from Tartarus's vicinity and not tell the difference from its namesake cocktail. While I have learned it is acceptable to laugh at his suggestion, it is a challenge I shall nevertheless continue to decline!

 SERVES:
1

 ICE:
Standard, 1-inch cubes

 GLASS:
Highball or collins

½ ounce white rum

½ ounce silver tequila

½ ounce gin

½ ounce vodka

1 ounce green apple schnapps

1 ounce melon liqueur

1 ounce pineapple juice

½ ounce lemon juice

2 to 3 ounces tonic water

Garnish:
Green and/or red maraschino cherries

Special Equipment:
Blacklight

1. Fill a highball glass two-thirds full with ice.

2. Add the rum, tequila, gin, vodka, green apple schnapps, melon liqueur, and juices.

3. Fill with tonic and give the drink one quick stir.

4. Spear the cherries on a cocktail skewer and garnish the drink.

5. Shine a blacklight to see the radioactive glow.

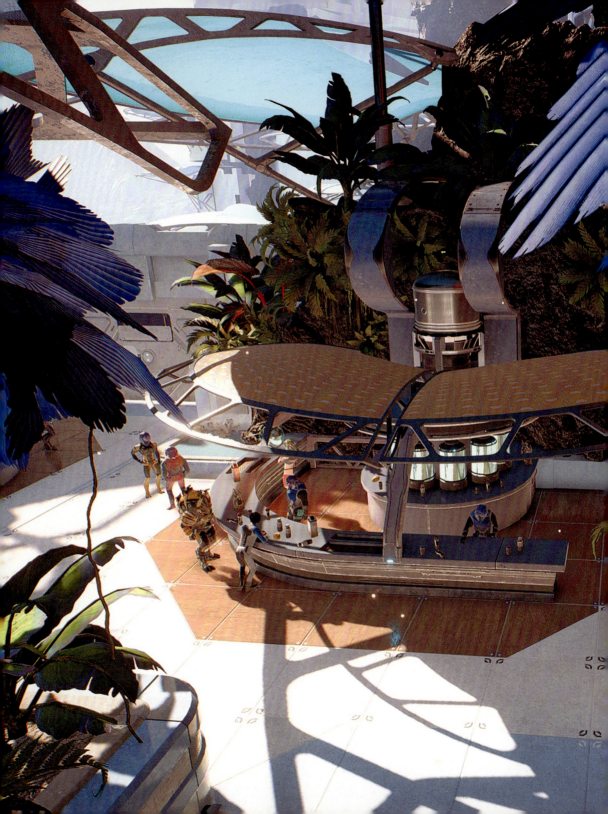

ANDROMEDA BAR SNACKS

Angara families are very large, especially when compared to those coming from the Milky Way. Parents, siblings, and cousins all come together to form a close-knit community whose bonds are strengthened by many things—but mostly by food! We are taught that cooking for others is a tangible expression of love and thus have a deep bench of recipes to draw from.

To be able to add to the collected recipes provided by Ambree T'Sia has been an exciting gift for the angara, so I hope that sharing the following recipes gathered from across Andromeda might return the favor—and help welcome our new friends as family. These dishes are some of my favorites and are perfect to share (and pair) with a drink.

"GINGERBEARD" COOKIES

"Gingerbeard" Cookies (the debate is still on as to whether these are human or asari in origin) are all the rage on New Tuchanka! After tasting a batch, I understand why—these odd little treats are sweet at first, then a spicy little kick of heat hits your mouth and the next thing you know, only crumbs remain. Nakmor Kesh provided a recipe that she secured prior to entering cryogenic slumber. I encourage you to make some immediately. (Double the recipe if you have a clan nearby who will smell them baking.) With such exotic ingredients, this must have been very hard to come by (unless you were a very wealthy individual) in the Milky Way!

| | MAKES:
24 | PREP TIME:
30 minutes | COOK TIME:
10 minutes | INACTIVE TIME:
30 minutes |

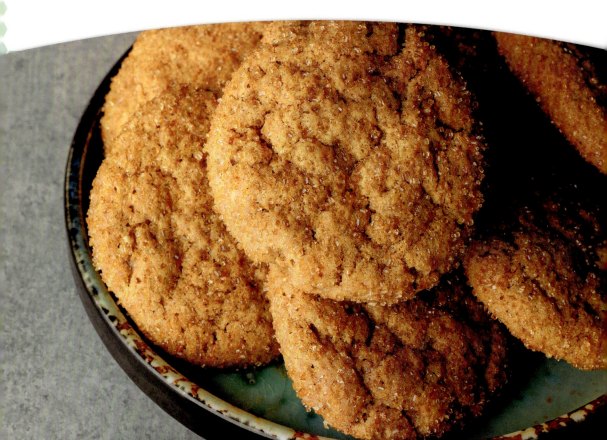

2½ cups all-purpose flour, leveled

2 tablespoons grated fresh ginger (I believe this is a plant)

1½ teaspoons ground cinnamon (A shelled animal of some sort?)

¼ teaspoon ground cloves (From a hoofed mammal, like a moose)

¼ teaspoon ground nutmeg (Not a nut; also, a plant!)

¼ teaspoon ground allspice (optional)

1 teaspoon baking soda

¼ teaspoon kosher salt

¾ cup unsalted butter, softened

1 cup light brown sugar

¼ cup dark brown sugar

1 large egg

1 tablespoon molasses

1 teaspoon vanilla paste or extract

1 tablespoon Tuchanka Dry (page 11) or orange liqueur (sub with additional molasses)

¼ cup raw turbinado sugar, for coating

Special Equipment:
Hand beater
Plastic wrap
Wire rack

1. In a medium mixing bowl, sift together the flour, ginger, cinnamon, cloves, nutmeg, allspice, baking soda, and salt.

2. In a separate mixing bowl, use a hand beater to cream together the butter and both the light and dark brown sugars. Beat in the egg, molasses, vanilla paste, and Tuchanka Dry.

3. Gradually stir the flour mixture into the wet mixture until well combined.

4. Form the dough into a ball and wrap with plastic wrap. Let the dough chill in the fridge for 30 minutes. Once chilled, preheat the oven to 350°F. Line two standard cookie sheets with parchment paper.

5. Shape the dough into twenty-four balls, each about the size of a ping-pong ball. Place the turbinado sugar in a small shallow bowl and roll each ball in the sugar until coated. Place the cookies about 2 inches apart on the prepared parchment-lined cookie sheets. Flatten each cookie slightly with the bottom of a glass.

6. Bake for 8 to 10 minutes, switching racks about halfway through. Remove from the oven and allow the cookies to cool on the baking sheets for about 5 minutes before transferring them to a wire rack to cool completely.

VARREN STEAK BITES

This is a savory steak bite dish with tangy, bright green herb dipping sauce. According to the archives, varren were creatures native to the krogan homeworld of Tuchanka. They were sought after for their cunning, ferocity, and even companionship! As well as their taste . . . Oh, and some were raised as beasts of war. But to Drack, they were most useful for eating, and Fishdog Food Shack was renowned for their recipe ("Fishdog," apparently, was a nickname for a subgenus of varren with metallic silver scales). I have trouble equating friends as food, but seeing as all varren meat that exists in Andromeda is cloned, I can simply enjoy them with a side of Pyjak Sauce!

 SERVES:
4 to 6

 PREP TIME:
30 minutes

 COOK TIME:
10 minutes

 INACTIVE TIME:
None

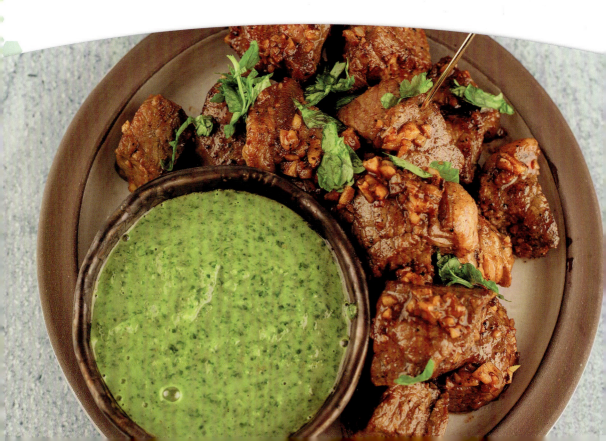

For the steak bites:

1½ pounds rib eye, New York strip, or tenderloin

1 teaspoon salt

⅓ teaspoon pepper

1 tablespoon extra-virgin olive oil

2 tablespoons unsalted butter

4 or 5 cloves garlic, minced

¼ teaspoon red pepper flakes

Flat-leaf parsley, chopped, for garnish

For the pyjack sauce:

½ cup flat-leaf parsley, packed

½ cup cilantro leaves, packed

¼ cup fresh mint leaves (optional)

1 small shallot

2 tablespoons red wine vinegar

1 clove garlic

1 teaspoon honey

1 teaspoon lime juice

½ teaspoon kosher salt

¼ teaspoon ground cumin

¼ teaspoon dried oregano

¼ teaspoon red pepper flakes

½ cup extra-virgin olive oil

Special Equipment:

Food processor

Large cast-iron skillet

1. Cut the steak into bite-size pieces and season liberally with salt and pepper. Set them aside at room temperature while you prepare the Pyjak Sauce.

2. Place all the sauce ingredients in a blender or food processor and pulse until the herbs and shallot are minced but not completely liquified. Place in a shallow bowl and set aside.

3. Time to cook the steak. Heat the olive oil in a large cast-iron skillet over high heat. Once the oil is hot, add one steak piece. It should start to sizzle as soon as it touches the oil, if it does not, the oil needs to be hotter.

4. Once the oil is hot enough, add more steak pieces. You may need to add them in batches to prevent overcrowding the skillet. Let the pieces brown on one side for about 2 minutes before flipping the pieces over. Continue cooking for another 1 to 2 minutes until the pieces are golden brown on all sides. You want to cook just long enough to get a good sear on both sides; the center should be a nice medium-rare. It should have a warm, reddish-pink center. If you're able to measure with a meat thermometer, the ideal temperature for the interior is 130°F to 135°F.

5. Transfer the steak bites to a serving plate and set aside. In the same skillet you cooked the steak, add the butter and turn the heat down to medium. Once the butter has melted, add the garlic and red pepper flakes. Cook for 30 seconds, stirring frequently, just until the garlic becomes fragrant. Be careful not to burn the garlic.

6. Pour the garlic butter over the steak bites and toss well. Garnish with parsley and serve with the Pyjak Sauce either on the side (for dipping) or drizzled on top of the steak bites.

MOVIE NIGHT! TARVAV, POPCORN & GRAXEN

Movie night here is a tradition that started as a way for the crew of the survey ship Tempest to relax during their downtime. Word quickly spread throughout the Nexus and now the entire space station offers regular movie nights to help build camaraderie. And it helps aliens such as myself further familiarize ourselves with Milky Way culture, where this custom has a storied history. The only thing to make movie night more enjoyable is a large, heaping bowl of popcorn . . . Andromeda style. Dr. Suvi Anwar enjoys hers with crispy angaran Tarvav and Vetra mixes in graxen. Smother the entire thing with McSorley's Cloaca Margarine for an extra-salty treat! So many ingredients for such a simple dish. But sometimes the quest for the perfect snack is its own worthy entertainment!

 SERVES:
6 to 8

 PREP TIME:
20 minutes

 COOK TIME:
40 minutes

 INACTIVE TIME:
None

For the tarvav:

1 bunch kale

1 tablespoon extra-virgin olive oil

Salt

Pepper

For the popcorn & graxen:

¼ cup popcorn kernels

¼ cup sorghum kernels

2 tablespoons vegetable, canola, grapeseed, or peanut oil, plus more as needed

1. First, make the cloaca margarine. In a small saucepan, heat the ghee over medium-low heat until melted. Add the garlic and let cook for a minute or two until the garlic has cooked and the butter is infused with the garlic. Add the lemon juice and seasonings and stir to combine. Cook for another minute or two, then transfer to a small container. Set aside.

2. Now start the tarvav. Preheat the oven to 300°F. Line a rimmed baking sheet with parchment paper. With a sharp knife, remove the kale leaves from the thick stems. Tear the leaves into tortilla chip–size pieces. Add the kale to a gallon-size grip-seal bag and add the olive oil, salt, and pepper. Shake the bag to coat the chips with the oil and seasoning.

3. Spread the kale pieces out in an even layer on the baking sheet without overlapping. Bake until the chips are crispy and the edges start to brown but are not burnt, about 20 to 25 minutes. Once done, transfer to a serving bowl.

For the cloaca margarine:

½ cup clarified butter (ghee)

2 or 3 cloves garlic, minced

1 tablespoon lemon juice

1 tablespoon Old Bay seasoning

1 teaspoon Cajun seasoning

Special Equipment:

Grip-seal bag

Large, thick-bottomed saucepan with lid

4. Meanwhile, make the popcorn and graxen. Heat the oil in a large thick-bottomed saucepan over medium-high heat. Test the oil by adding 4 or 5 popcorn kernels. Once they pop, add the remaining popcorn kernels. Cover the pot and remove it from the heat for 30 seconds. Return the pan to the heat and the popcorn should begin popping shortly. Once the popping begins, make sure the popcorn doesn't burn by gently rocking the pan back and forth. Once the popping slows to several seconds between pops, remove the saucepan from the heat, uncover, and transfer the popcorn to a serving bowl.

5. Add more oil to the saucepan and use the same method you used for the popcorn to pop the sorghum. Sorghum is smaller, though, so it may take less time. Add the popped sorghum to a serving bowl.

6. Before serving (either together or in separate bowls), drizzle the kale, popcorn, and sorghum with the cloaca butter to taste.

YANJEM'S SWEET DUMPLINGS

Angaran Resistance operator Buxil gave her brother Niilj two things: his code name *Shavod-Gaan* or "Whisper" (a playful jest at his reputation for being a bit of a loudmouth as a child) and an insatiable sweet tooth. Buxil's desserts, especially her Sweet Dumplings, are indeed a splendid thing. Niilj likes them with aged tavum (similar to spiced rum and bourbon) for "punch," and when I made some for Dutch and Anan, the pair found them to resemble French-Canadian grand-pères with some extra-warm spices thrown in.

 SERVES:
4 to 6

 PREP TIME:
30 minutes

 COOK TIME:
30 minutes

 INACTIVE TIME:
None

For the dumplings:

2¼ cups all-purpose flour

1 tablespoon granulated sugar

2 teaspoons baking powder

¼ teaspoon kosher salt

5 tablespoons unsalted butter, cold

1 cup buttermilk

For the tavum simmer sauce:

1½ cups golden syrup or pure maple syrup

1½ cups warm water

1 tablespoon vanilla paste or extract

2 cinnamon sticks

1 star anise

1 whole clove

1 tablespoon spiced rum

1 tablespoon bourbon

1. Preheat the oven to the "warm" setting, about 180°F.

2. In a Dutch oven or a large pot with a lid, stir together all the simmer sauce ingredients. Bring to a boil over medium heat, then reduce the heat to medium-low.

3. While the sauce is coming to a boil, make the dumpling dough. Add the flour, sugar, baking powder, and salt to the bowl of a food processor. Pulse to combine. Add the cold butter and pulse until the mixture resembles a coarse meal or breadcrumbs. Transfer to a medium mixing bowl. Slowly add in the buttermilk, stirring with a wooden spoon until well combined.

4. Use an ice-cream scoop or a large spoon to scoop and drop pieces of the dough into the simmer sauce. Be careful not to overcrowd the pot. Add the dough in batches, making sure there is space in between each dumpling. Cover the pot with a lid, reduce the heat to low, and simmer the dumplings until cooked through, about 10 minutes per batch. Depending on the size of your pot, you may need to flip the dumplings halfway through cooking if they're not completely submerged.

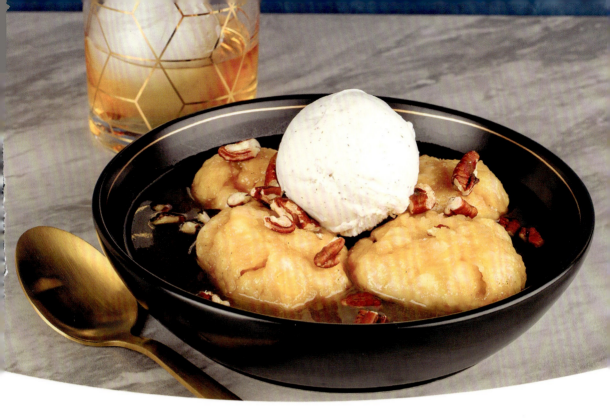

For serving:

Ground cinnamon

Vanilla ice cream (optional)

Toasted pecans, chopped (optional)

Special Equipment:

Dutch oven or large pot with a lid

Food processor

Ice-cream scooper or large spoon

Oven-safe dish

5. Transfer the cooked dumplings into an oven-safe dish and place in the warm oven. Repeat until all the dough is used. If the sauce reduces too much, add a little more liquid to thin it out.

6. Serve the dumplings warm in individual dessert bowls with the simmer sauce. If desired, add a scoop of vanilla ice cream and top with toasted pecans. Sprinkle with cinnamon.

About the Recipe Developer

Cassandra Reeder is an author, blogger, recipe developer, avid procrastinator, and enthusiastic napper. She launched her blog *The Geeky Chef* in 2008, bringing fictional food and drinks from a vast array of fandoms into reality with simple and fun recipes. Since then, a series of cookbooks based on the trailblazing blog have been published, including *The Geeky Chef Cookbook* and *The Geeky Bartender Drinks*. In 2023, she released *The Unofficial Princess Bride Cookbook*, a delectable homage to the classic cult film. Later that same year, she released *The Video Game Chef*, a culinary guidebook featuring recipes for video game foods spanning from the '80s to the present day. When not conjuring up recipes for fiction-inspired feasts and refreshments, Cassandra can be found reading, gaming, having adventures in Portland, Oregon, with her husband and two little geeks, and eating Klingon gagh straight from the fridge at 2 a.m.

About the Writer

Jim Festante has been a fan of *Mass Effect* since day one: He's lost count of total series playthroughs and worked as a producer on the SyFy TV show *Sci vs. Fi: Mass Effect 2*. Jim has fifteen-plus years in video game marketing for clients, including Xbox, Nintendo, and Sony. He has also written for various networks and media outlets including NBCUniversal, Comedy Central, MTV, the *Washington Post*, NBC Today, Discovery Networks, and *Slate Magazine*. His comics writing includes *The End Times of Bram and Ben* (Image), *Rick and Morty Presents* (Oni), *Field Tripping* (Amazon/Comixology Originals), and *Survival Street* (Dark Horse). Coincidentally, his birthday falls on N7 Day.

INSIGHT
EDITIONS

PO Box 3088
San Rafael, CA 94912
www.insighteditions.com

 Find us on Facebook: www.facebook.com/InsightEditions
Follow us on Instagram: @insighteditions

ISBN: 978-1-64722-999-3

Publisher: Raoul Goff
VP, Co-Publisher: Vanessa Lopez
VP, Manufacturing: Alix Nicholaeff
VP, Executive Project Editor: Vicki Jaeger
Publishing Director: Mike Degler
Senior Designer: Lola Villanueva
Editor: Alexis Sattler
Editorial Assistant: Jeff Chiarelli
Senior Project Editor: Nora Milman
Executive Project Editor: Mario Spano
Production Manager: Greg Steffen
Senior Production Manager,
Subsidiary Rights: Lina s Palma-Temena

Special Thanks to the BioWare Team:
Derek Watts – Franchise Art Director
Ryan Cormier – Narrative Editor
Michael Gamble — Executive Producer
Devon Gardner – Consumer Products Licensing Lead
Mad Bee – Fan Experience Producer
Carys Richards – Fan Experience Producer

Photography by Victoria Rosenthal

Insight Editions, in association with Roots of Peace, will plant two trees for each tree used in the manufacturing of this book. Roots of Peace is an internationally renowned humanitarian organization dedicated to eradicating land mines worldwide and converting war-torn lands into productive farms and wildlife habitats. Roots of Peace will plant two million fruit and nut trees in Afghanistan and provide farmers there with the skills and support necessary for sustainable land use.

Manufactured in China by Insight Editions

10 9 8 7 6 5 4 3 2 1